UNDERWATER COLORING BOOK & MARINE MAZES

TIKI-Ty COLORING BOOKS

© 2016 Tiki-Ty Coloring Books

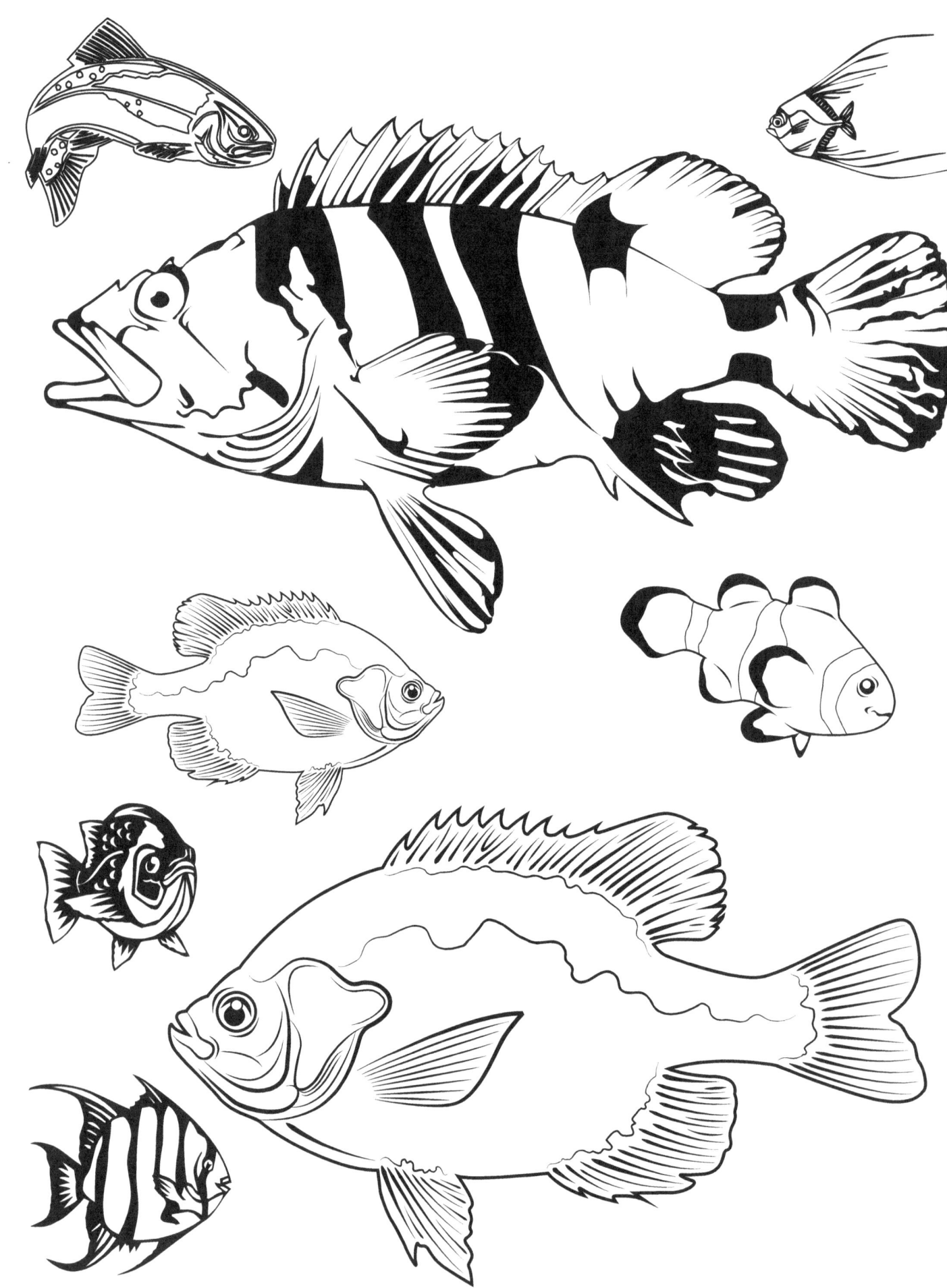

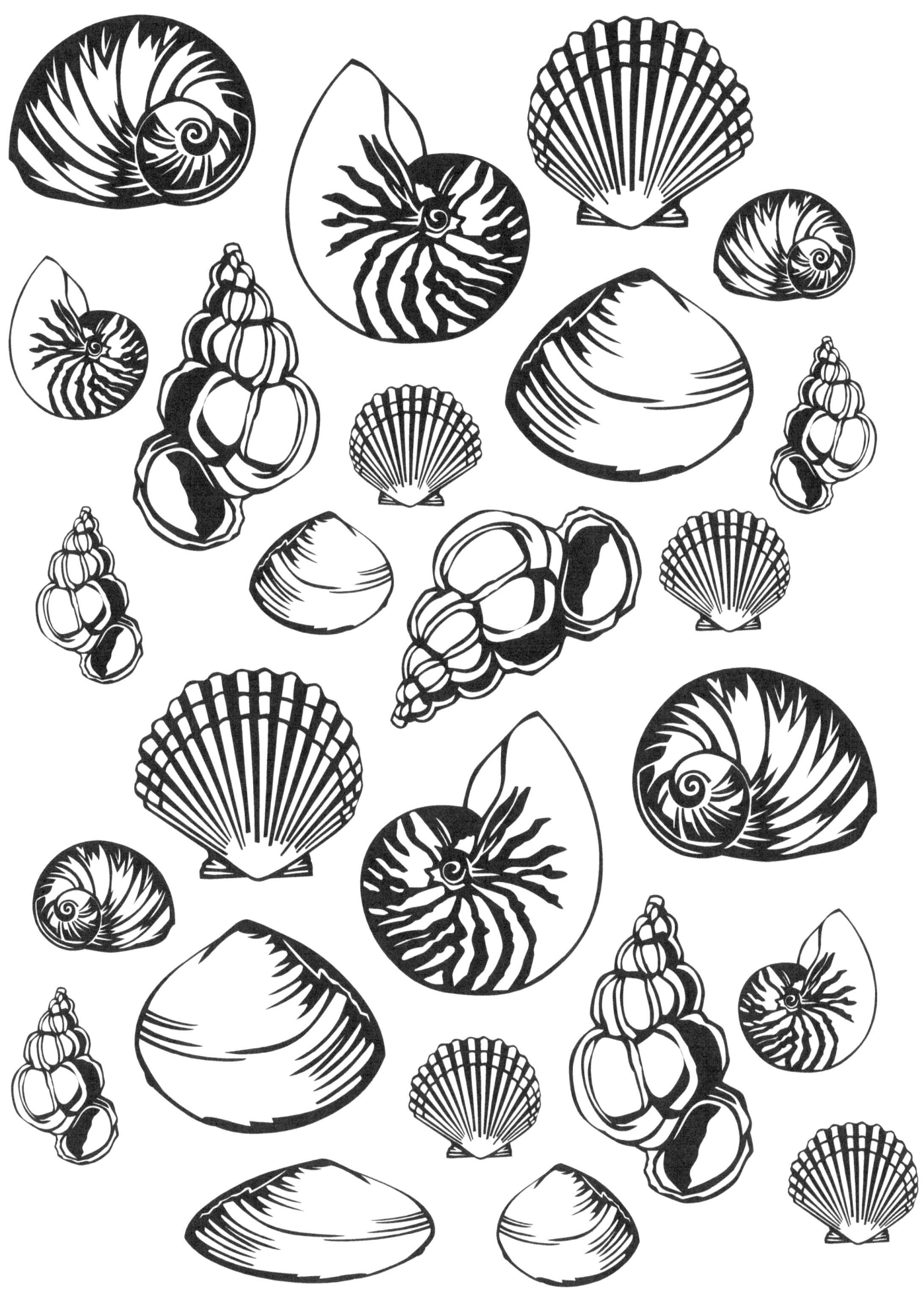

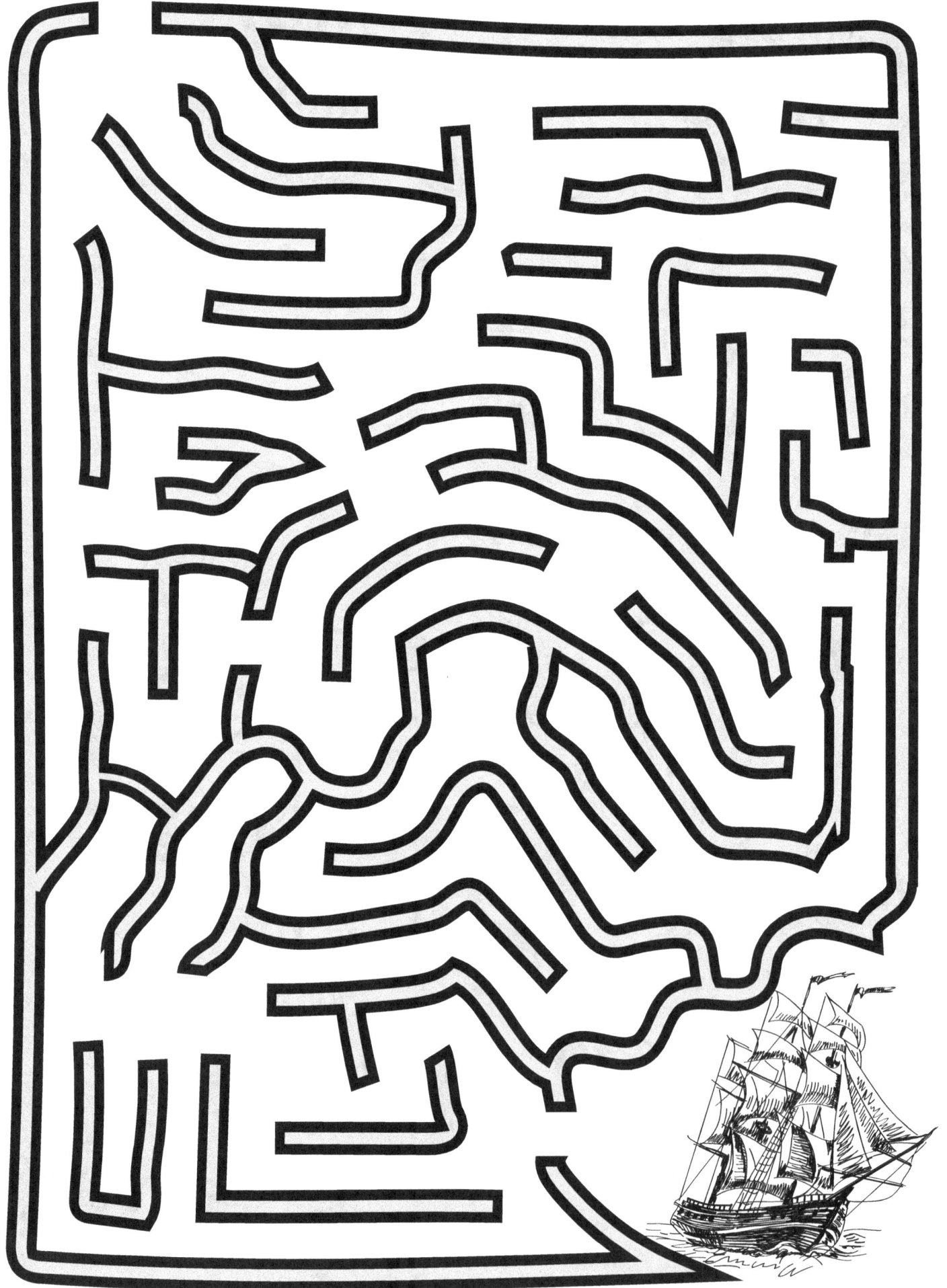

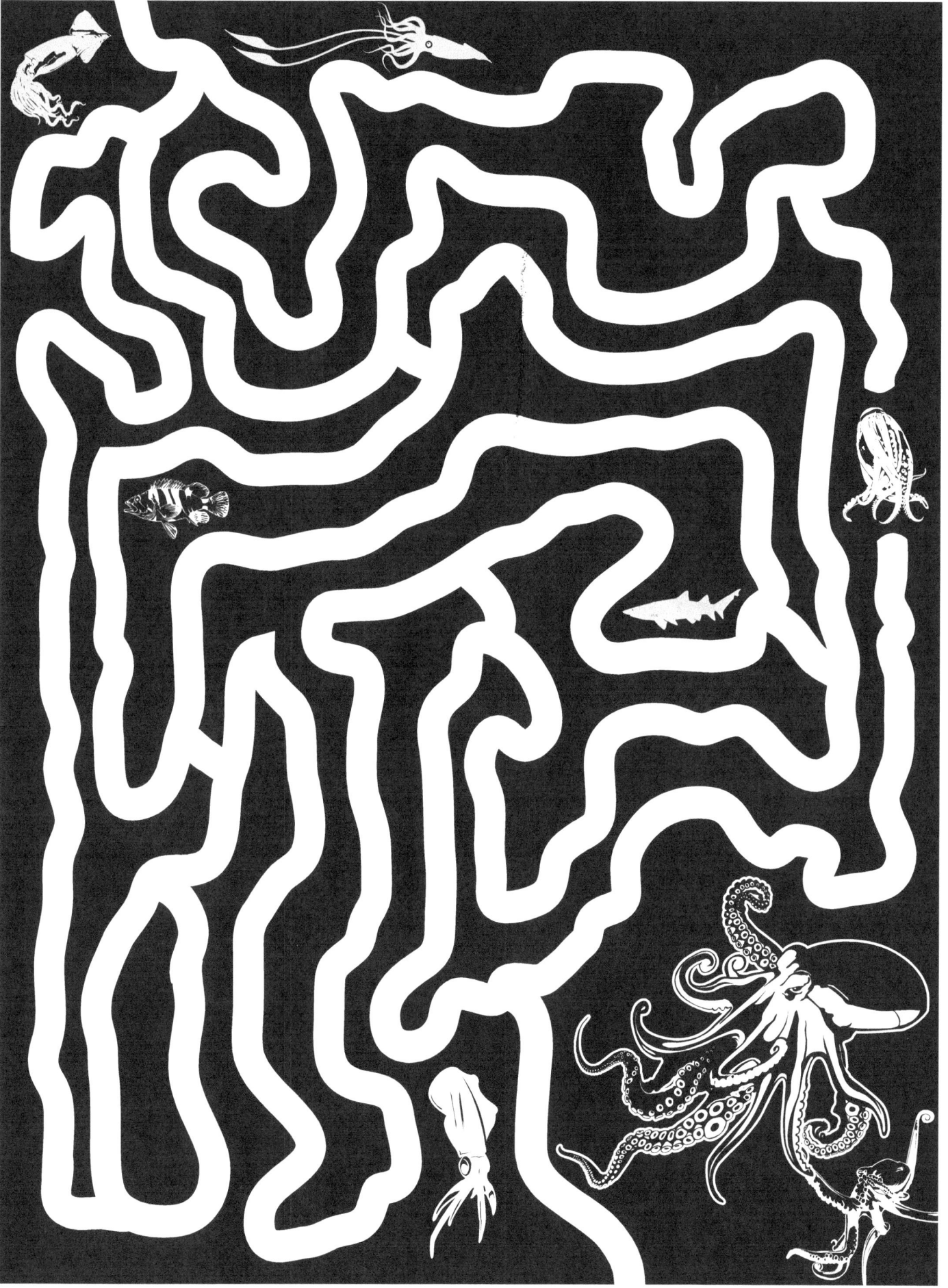

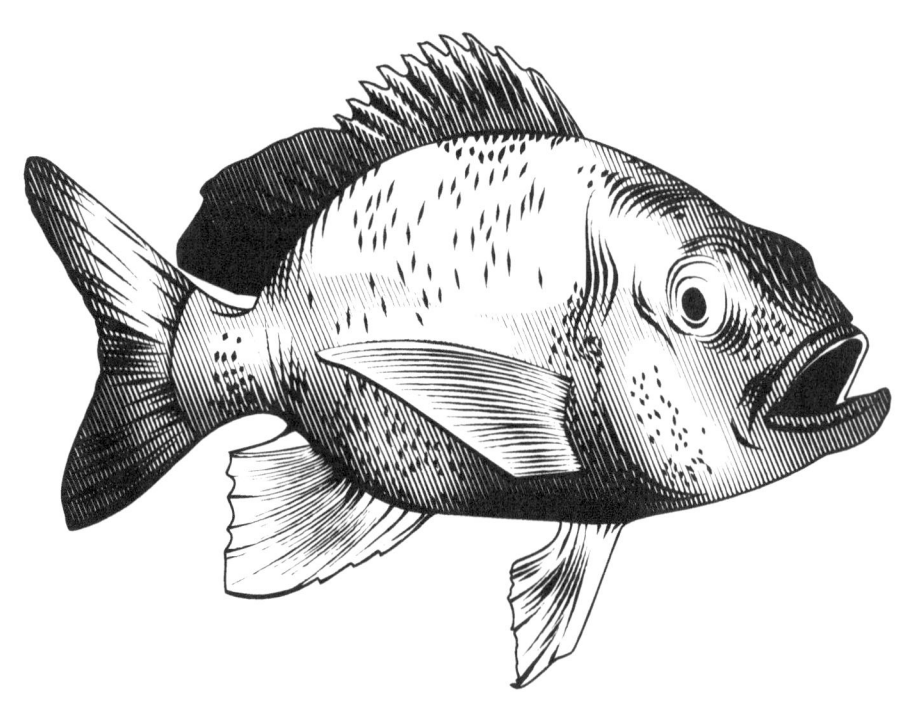

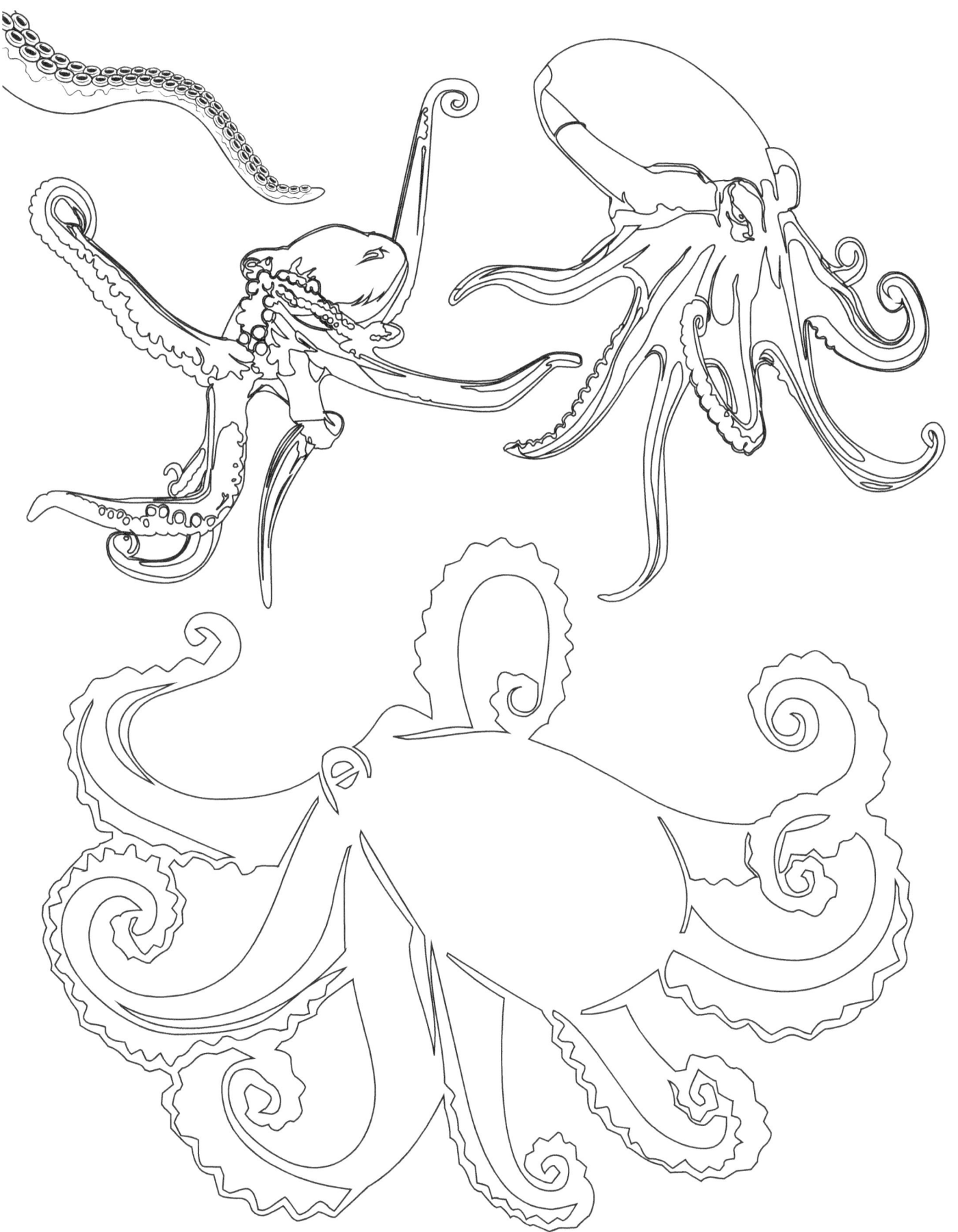

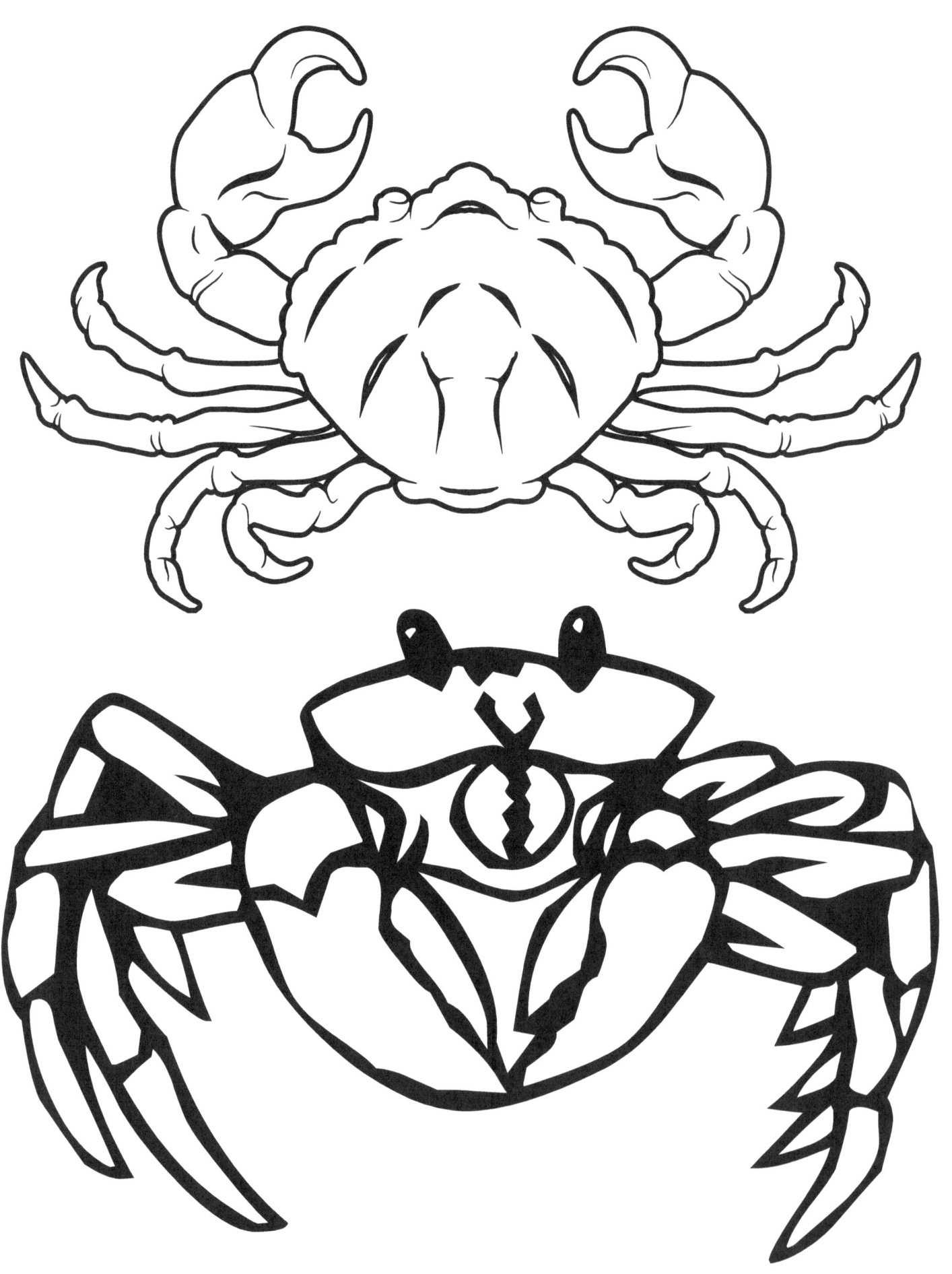

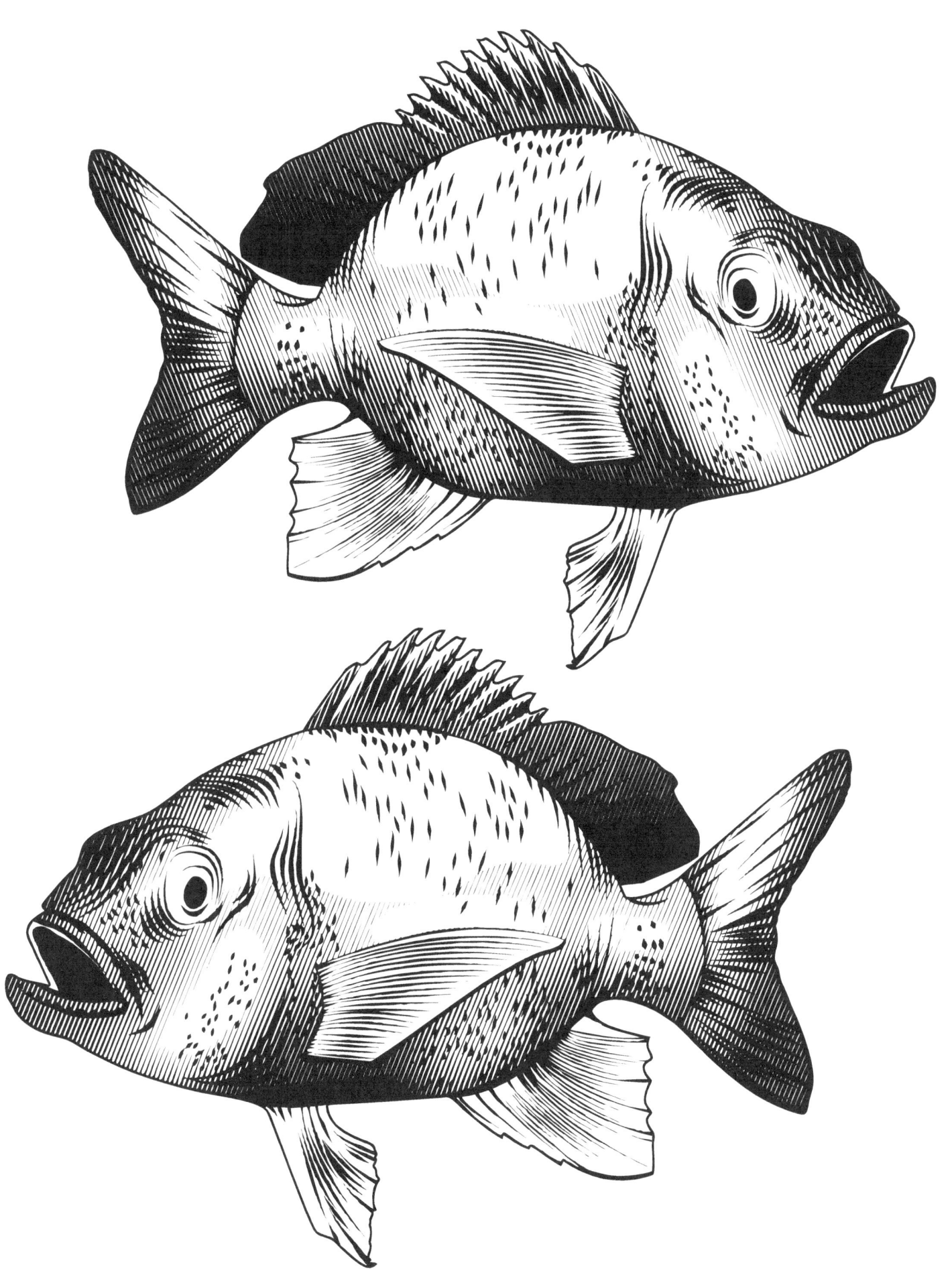

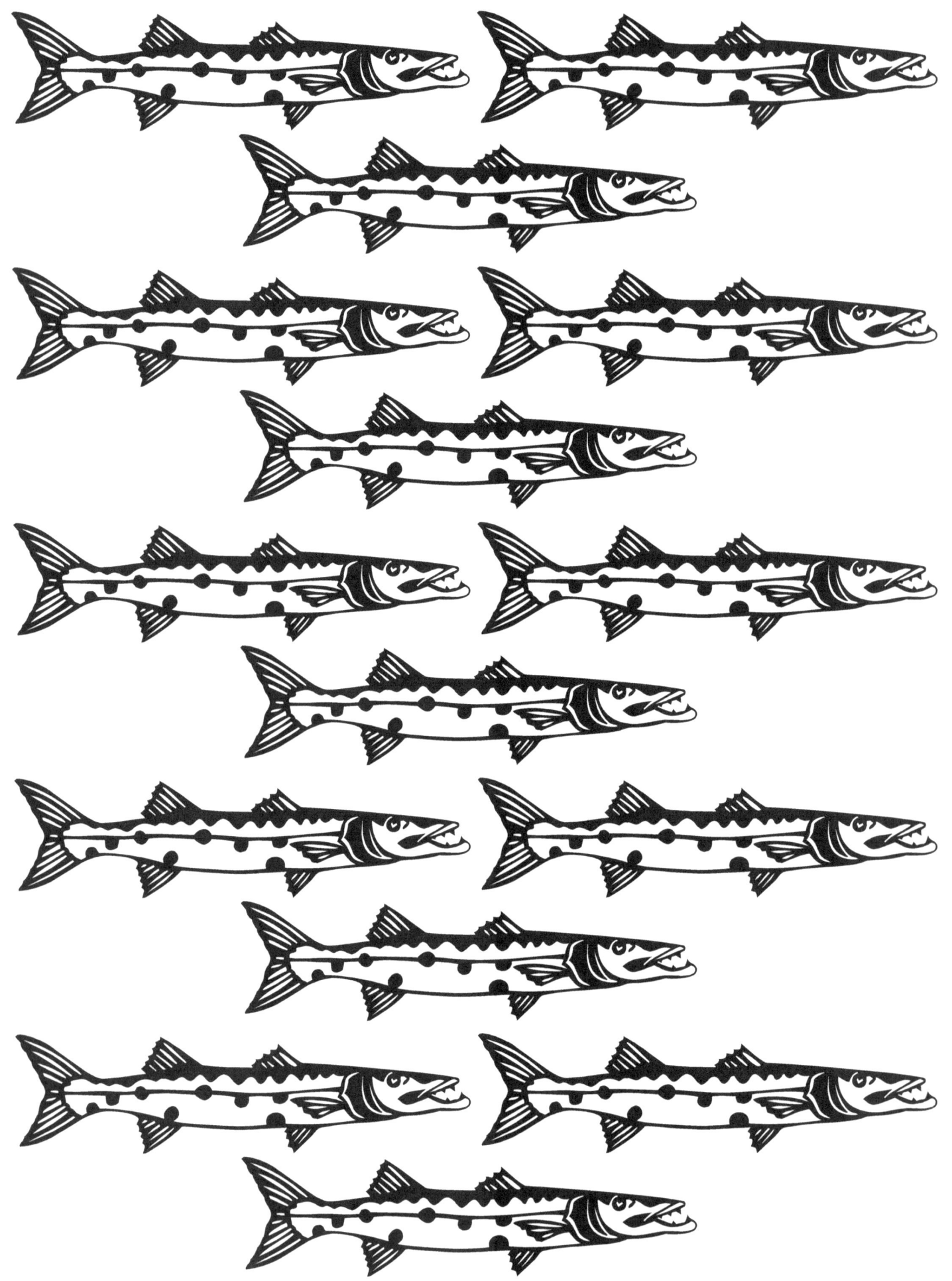

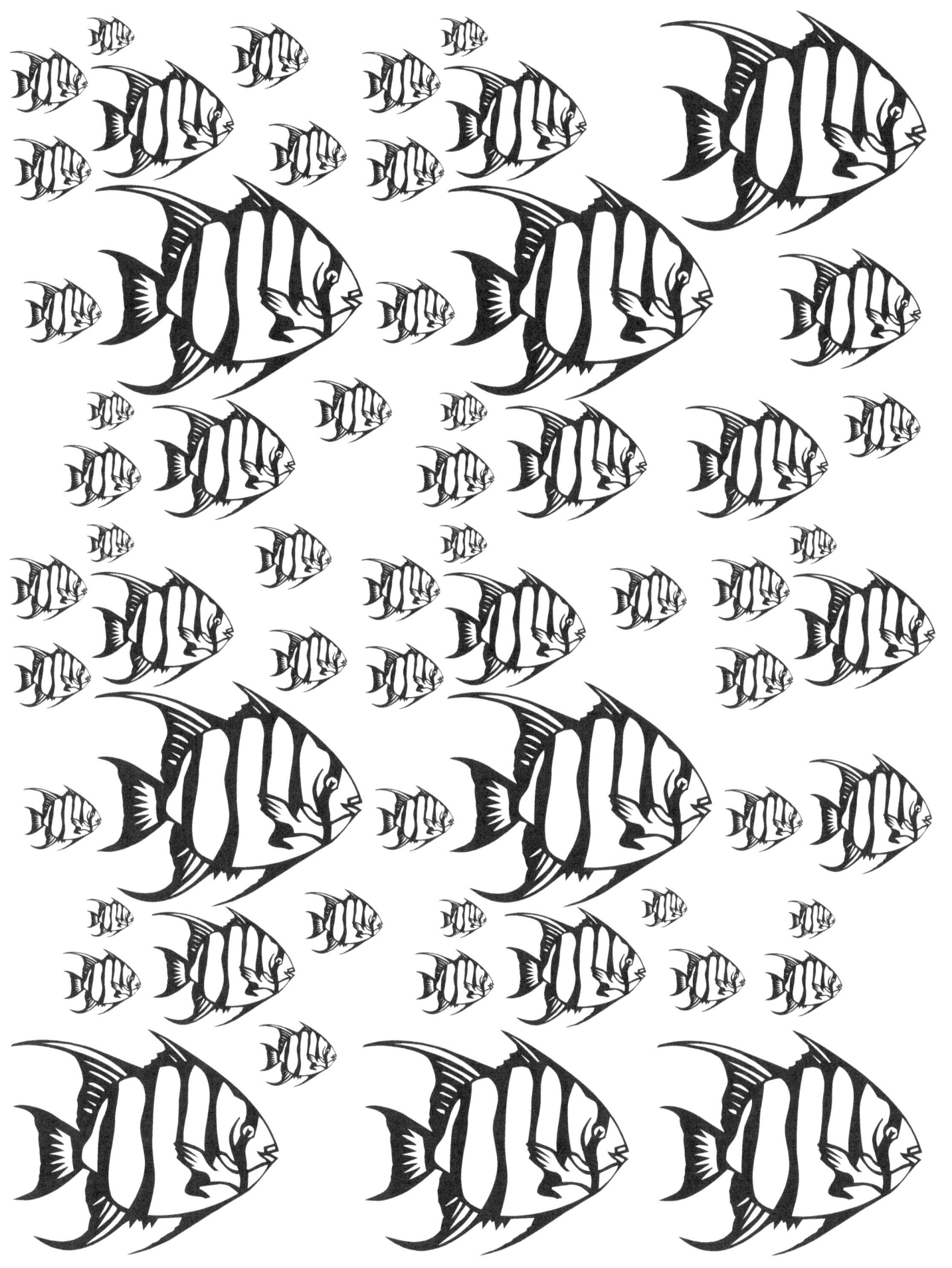

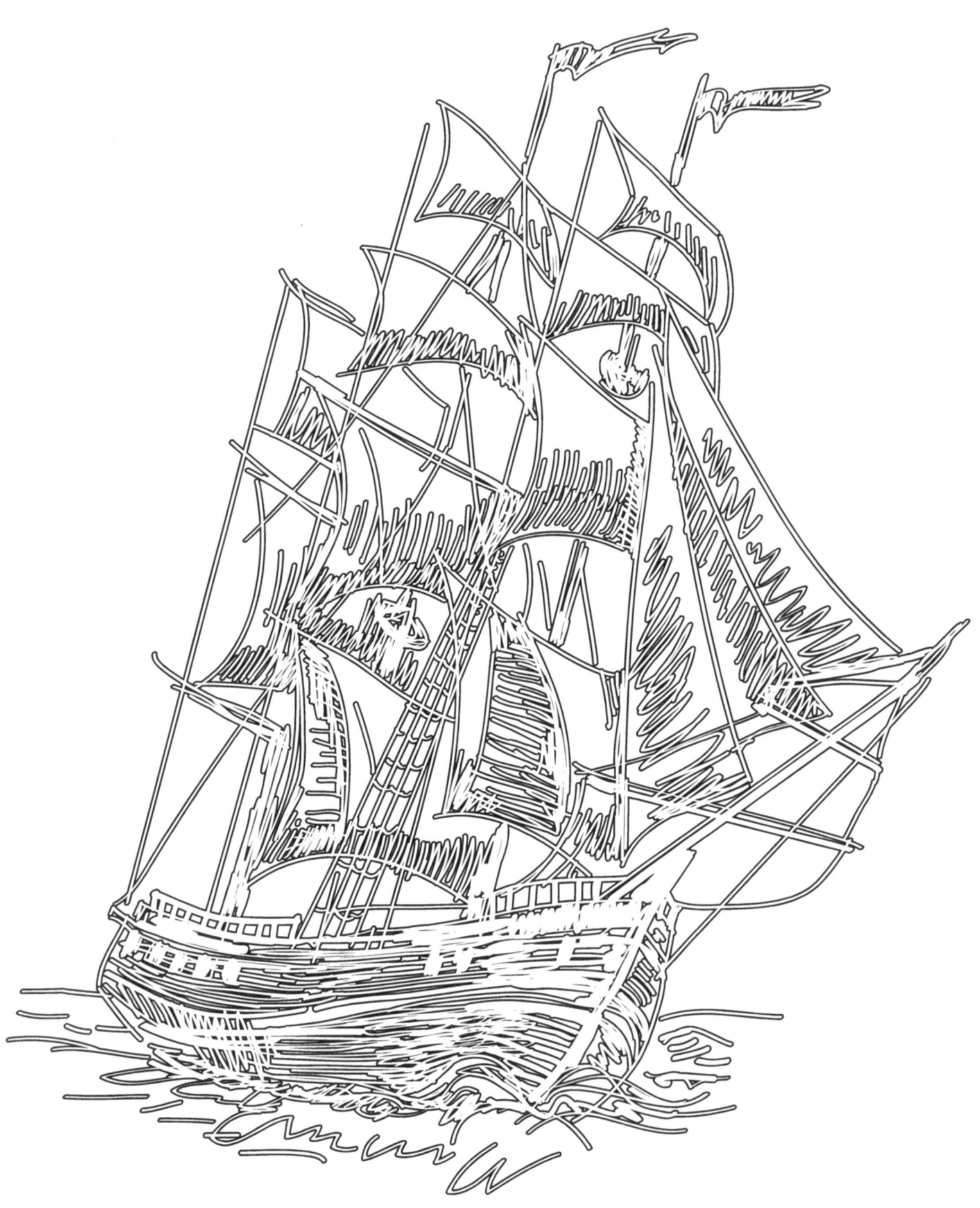

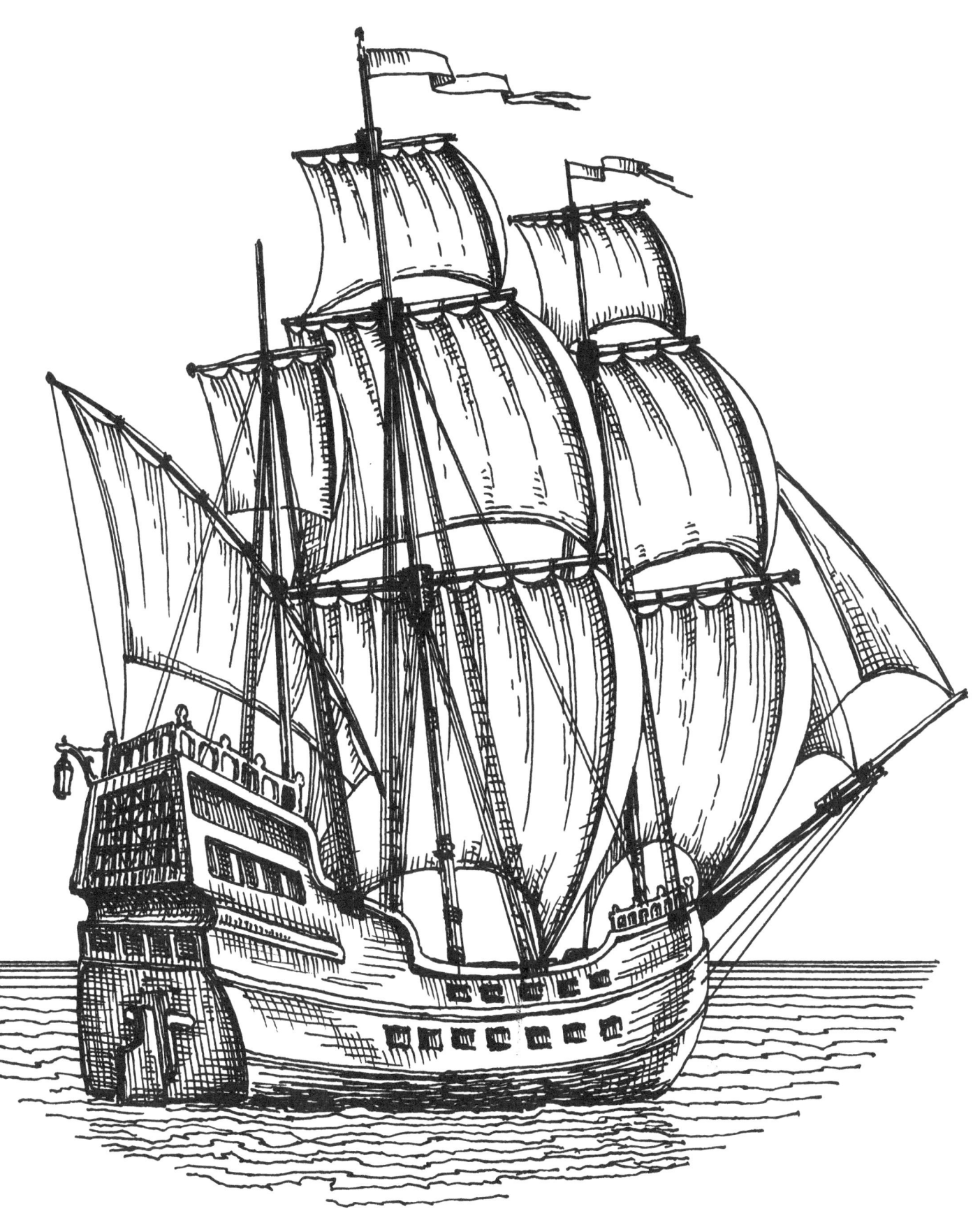

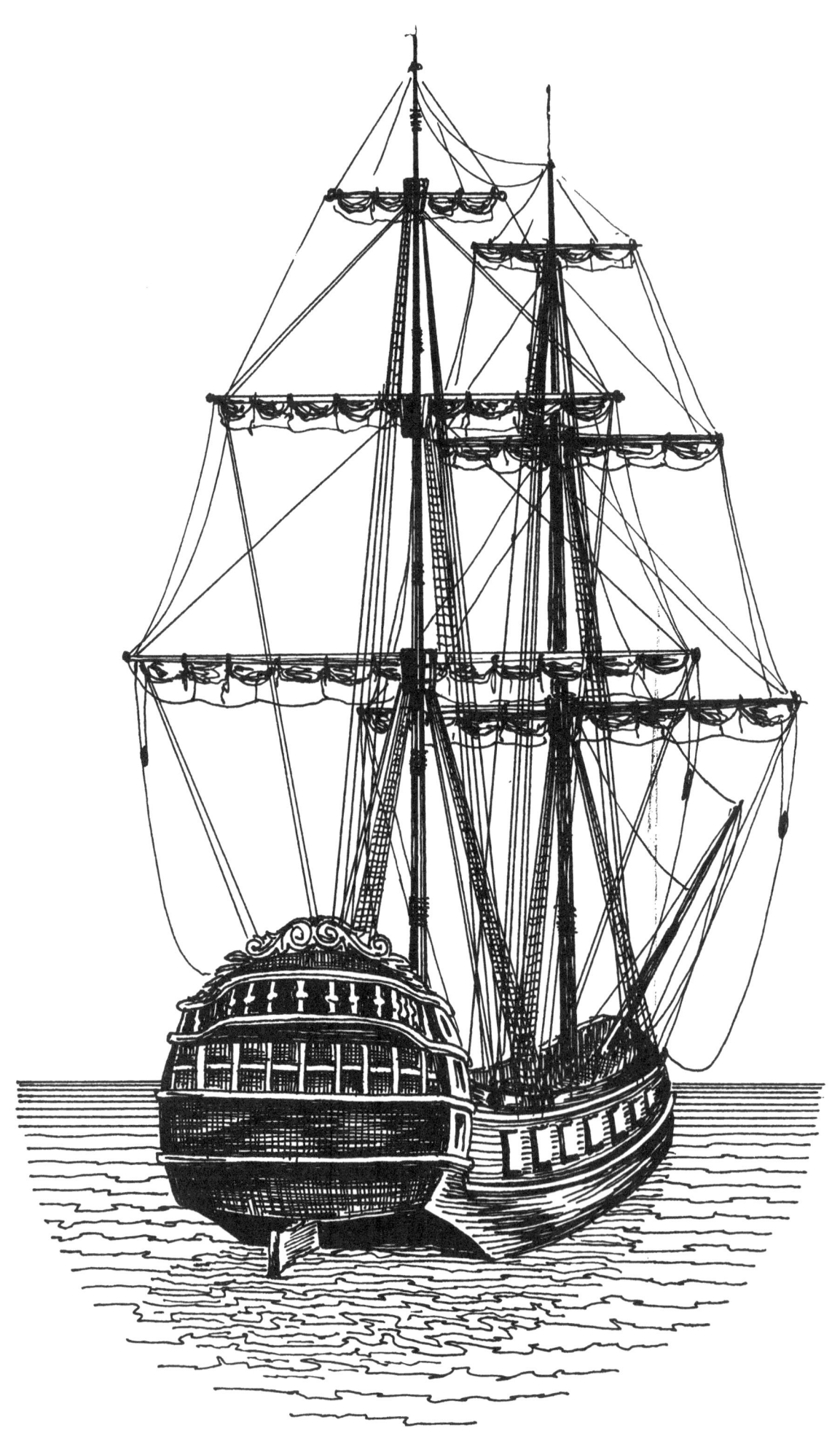

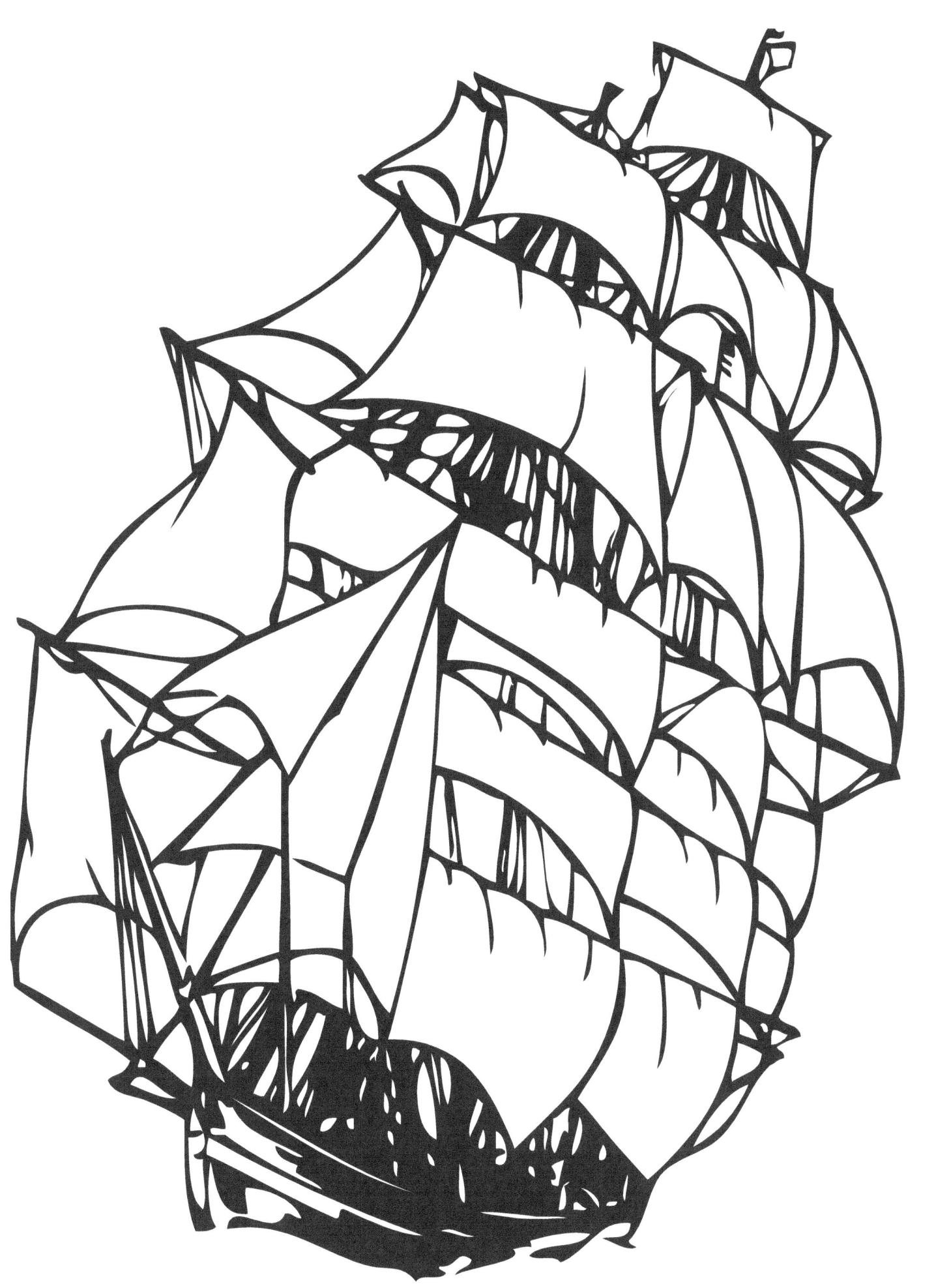

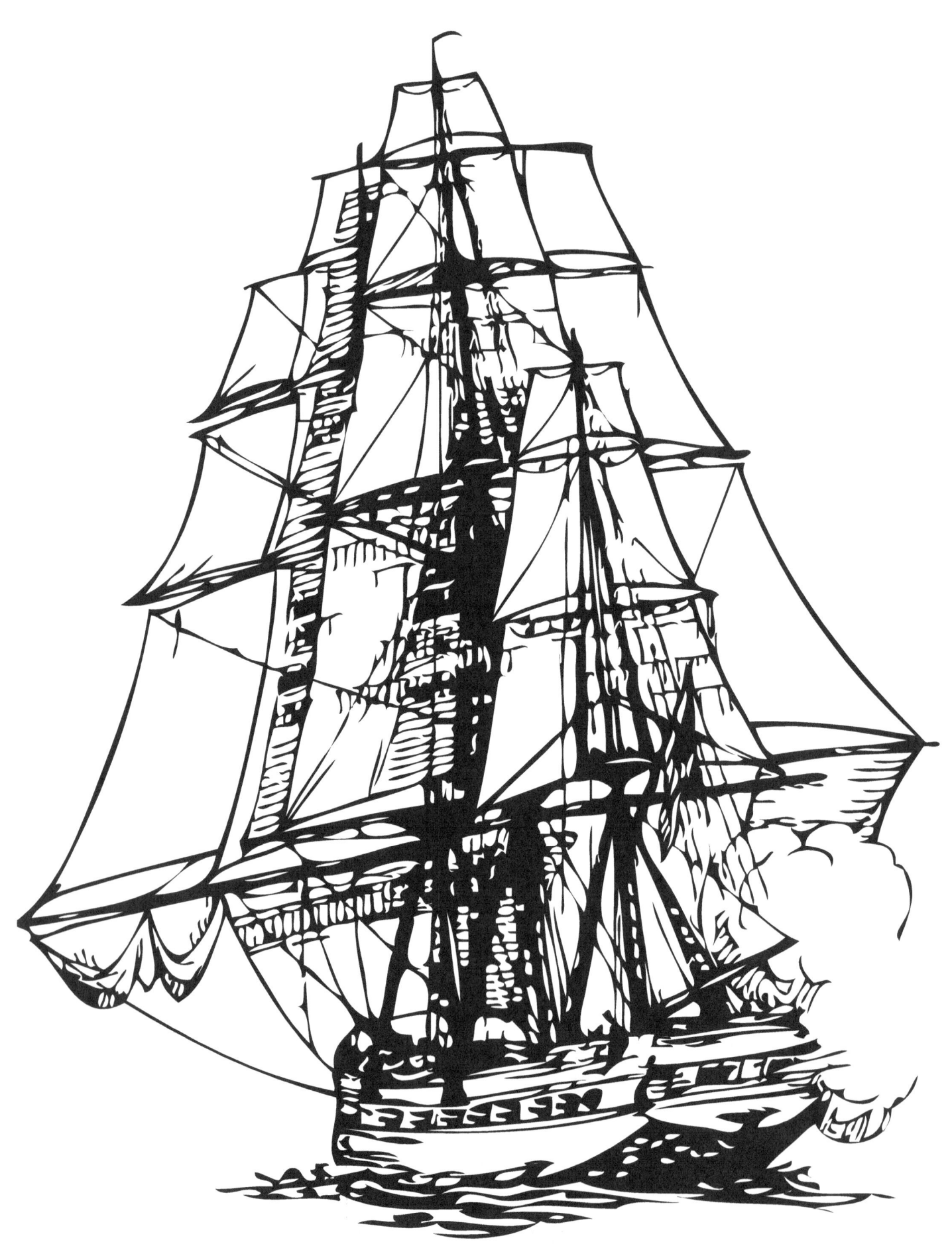

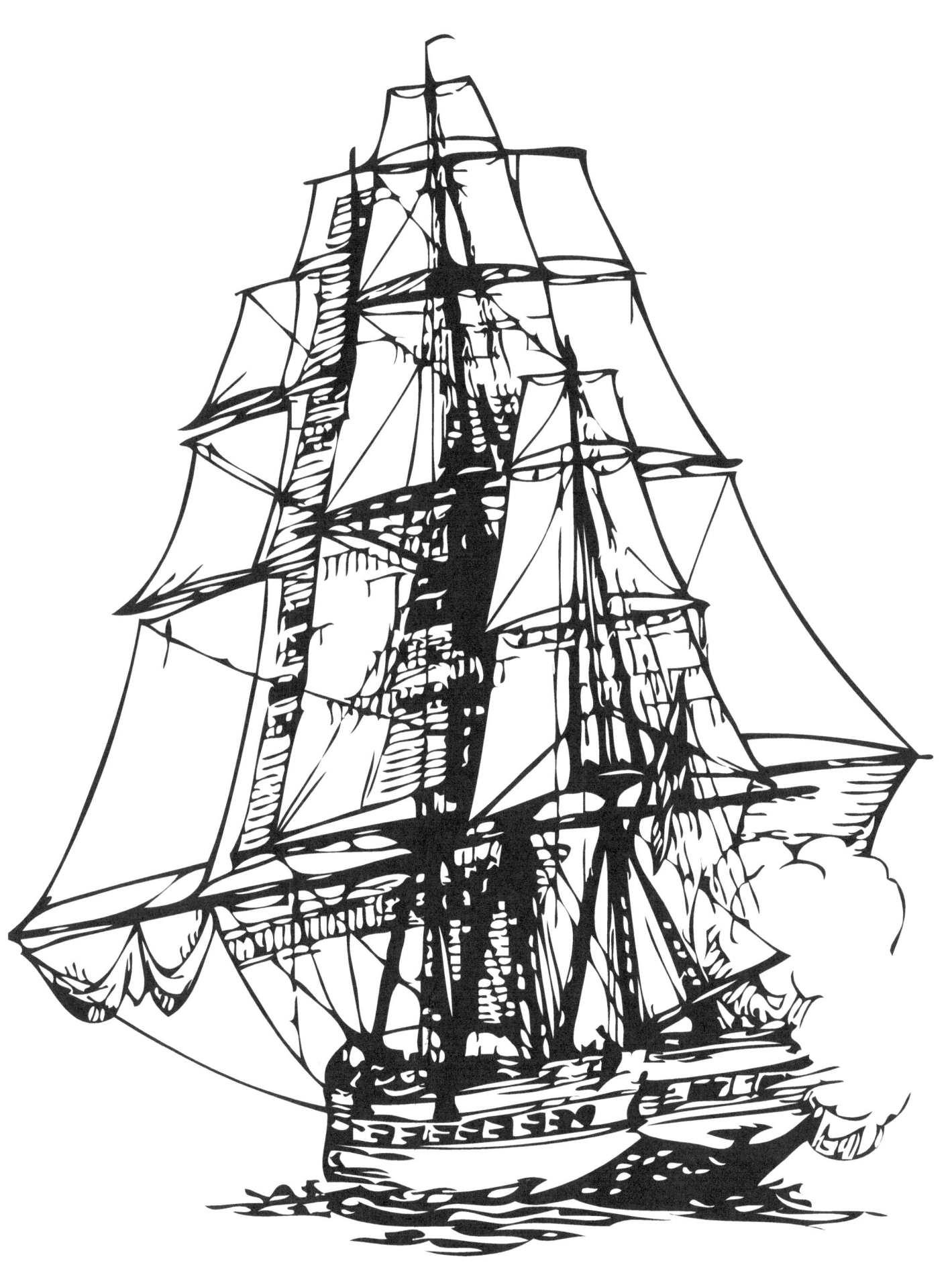

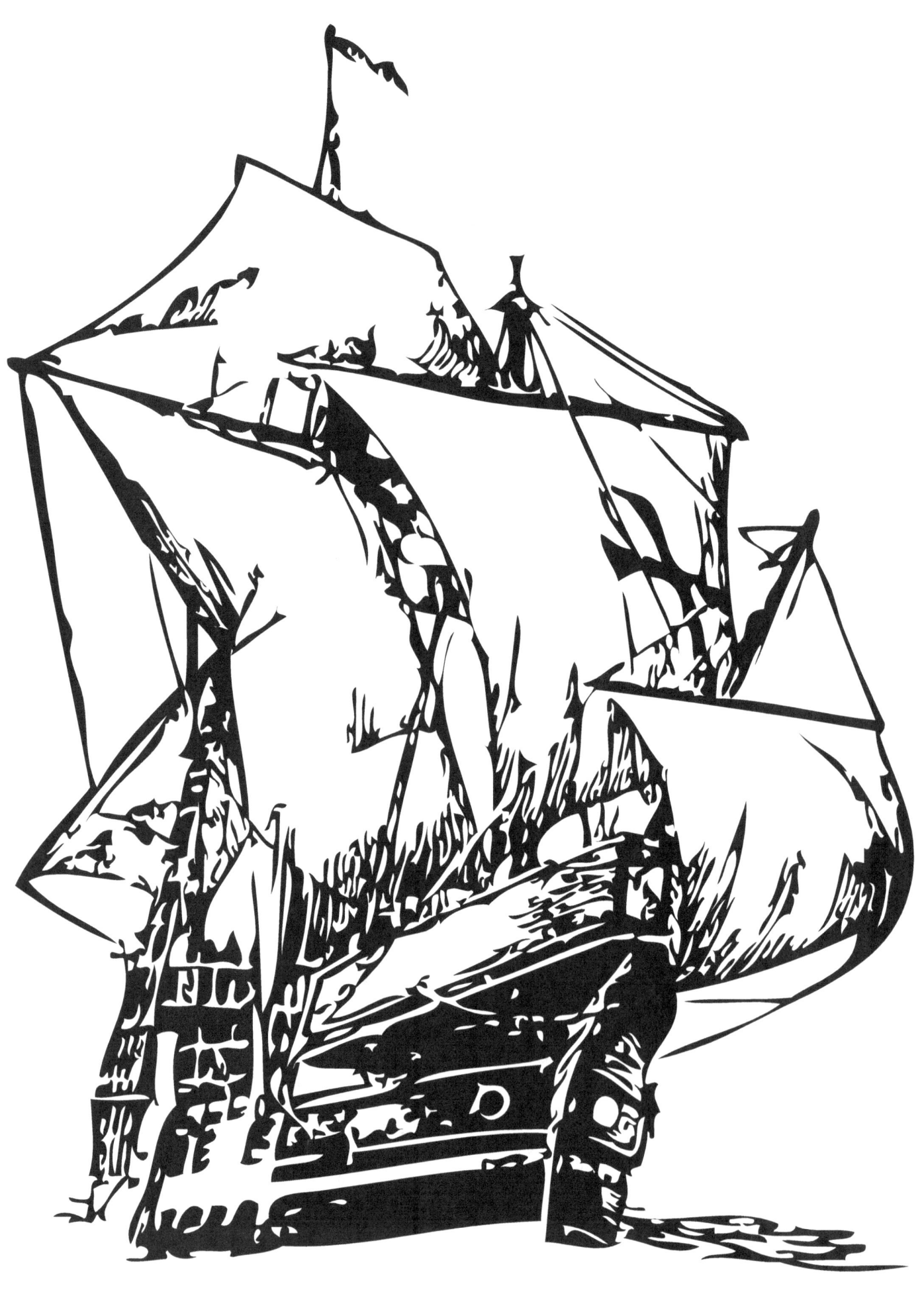

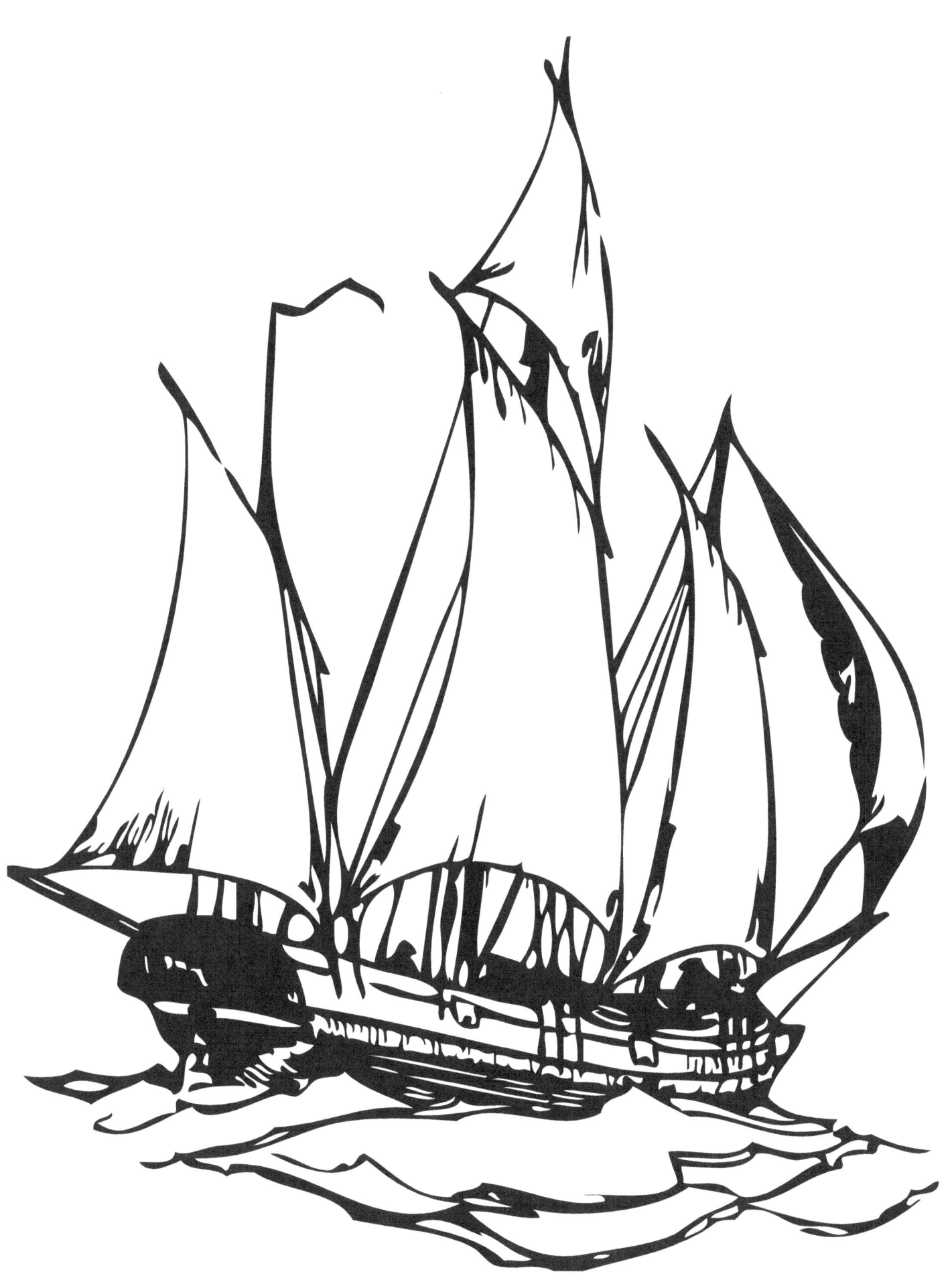

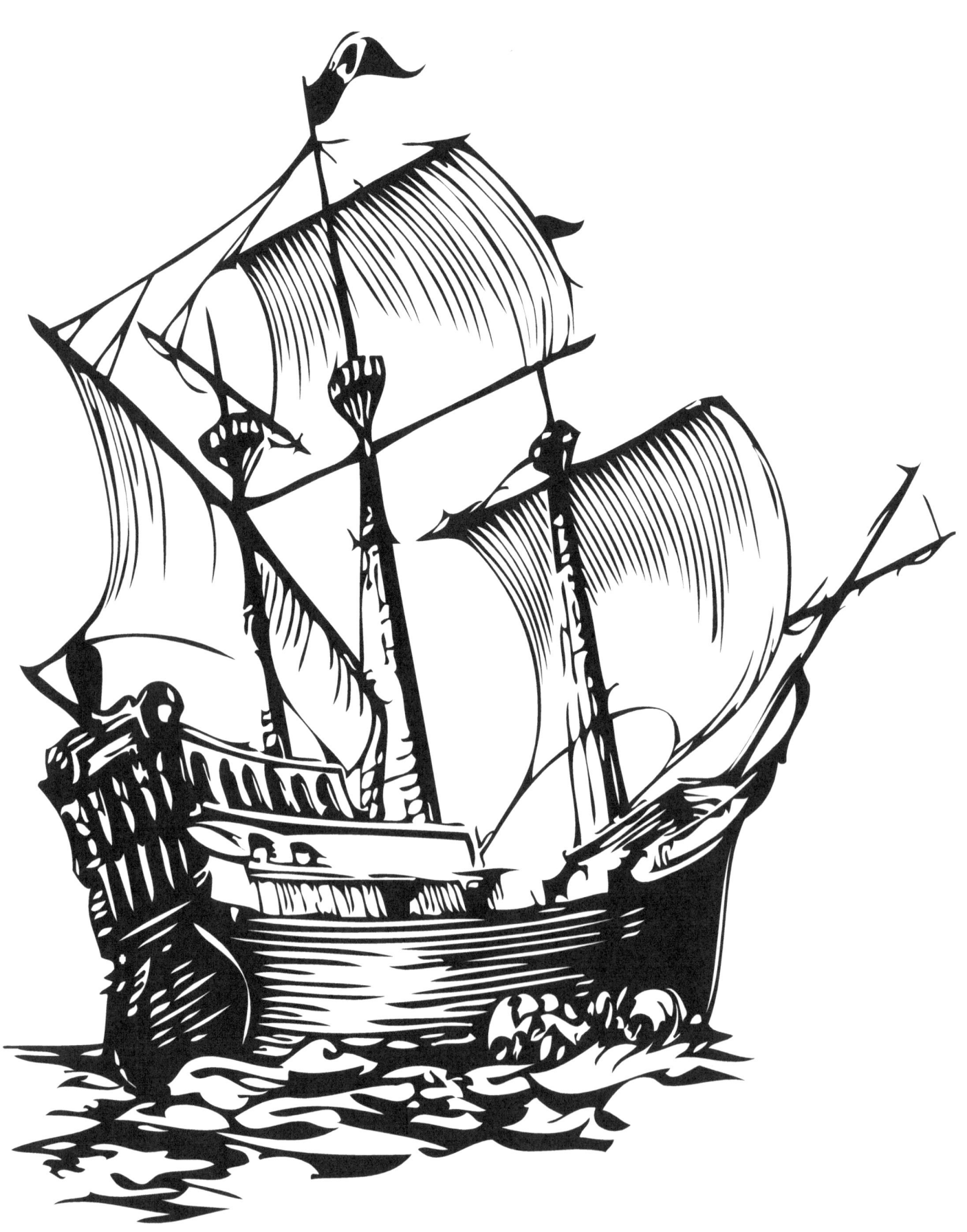

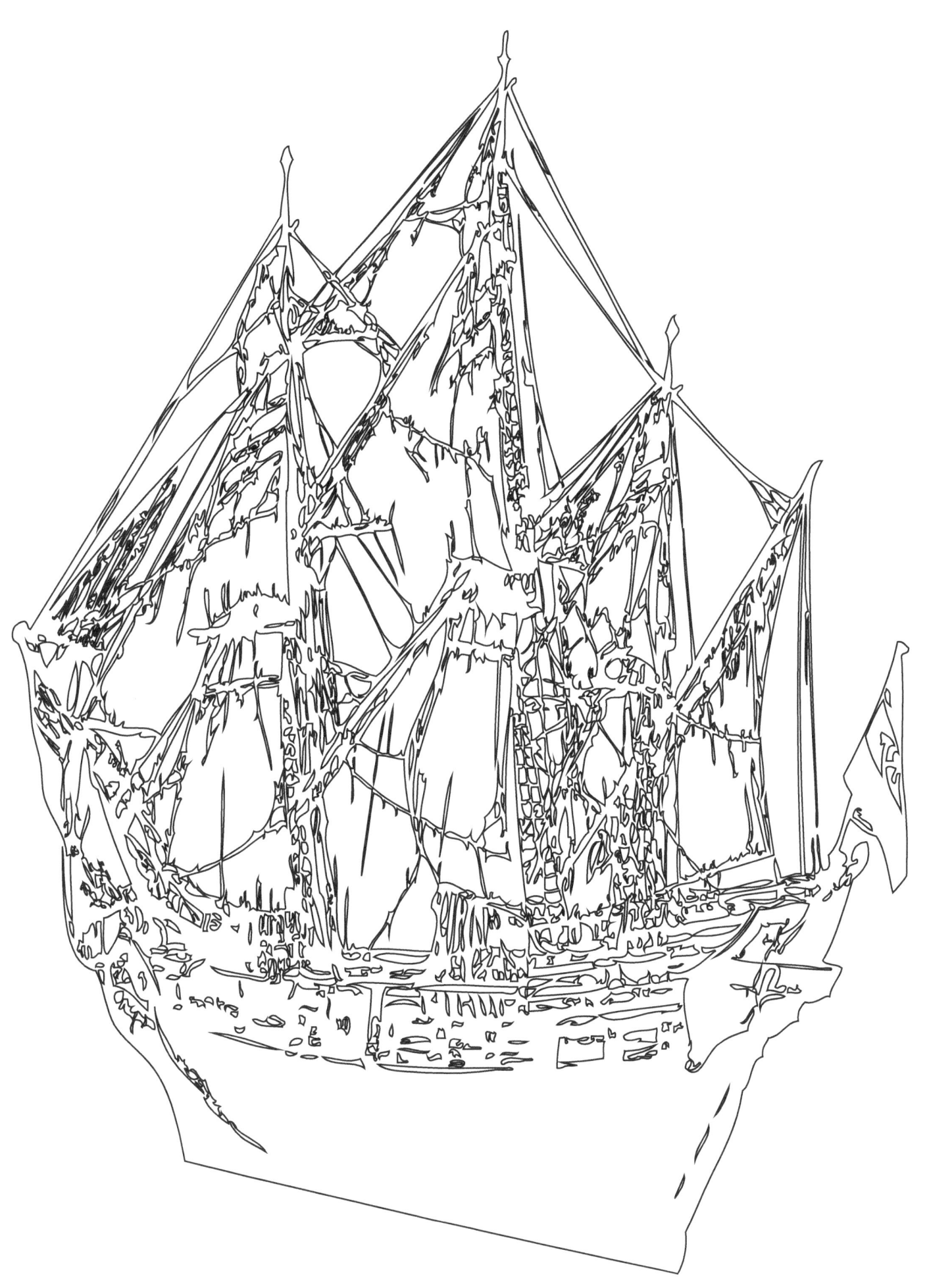

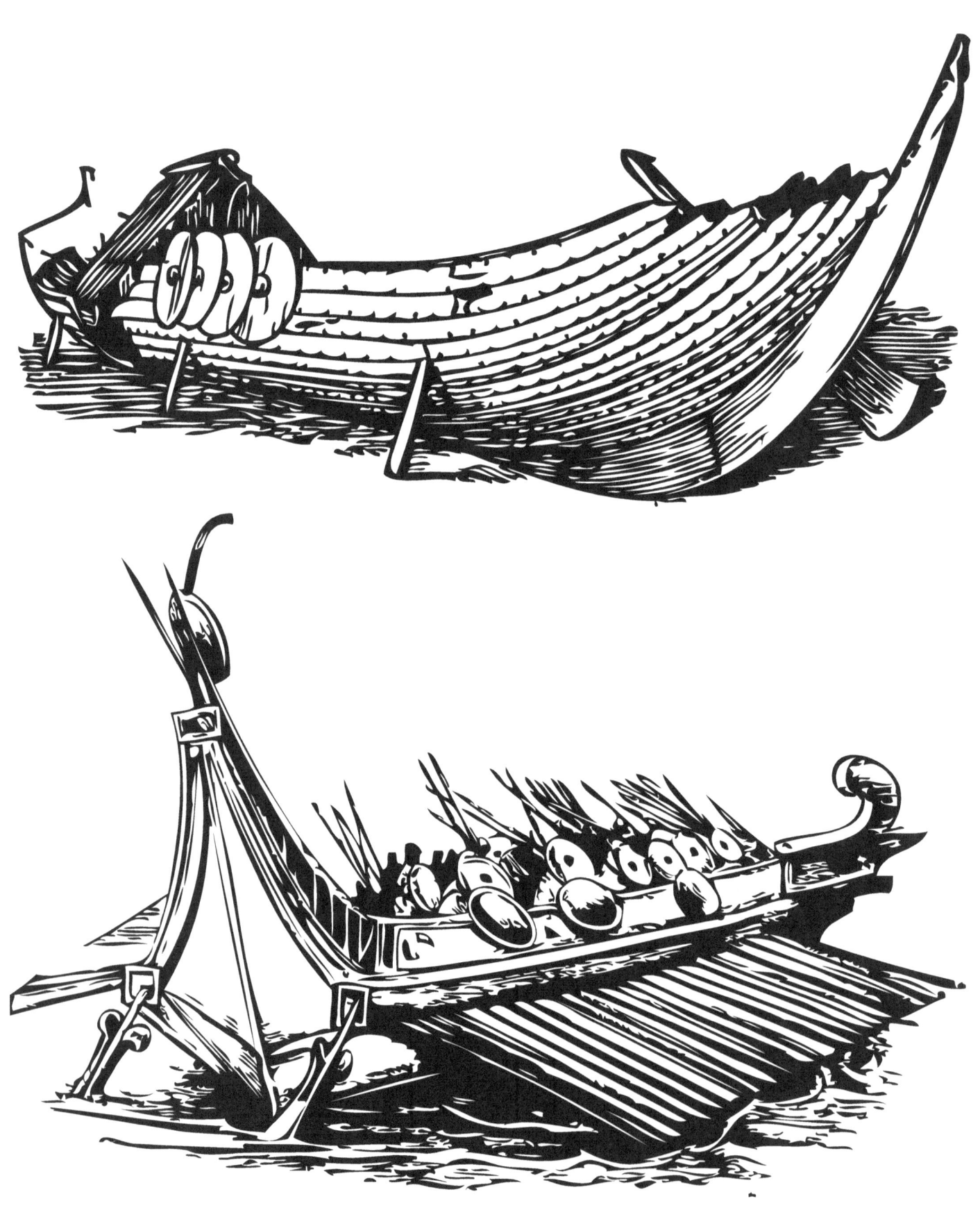

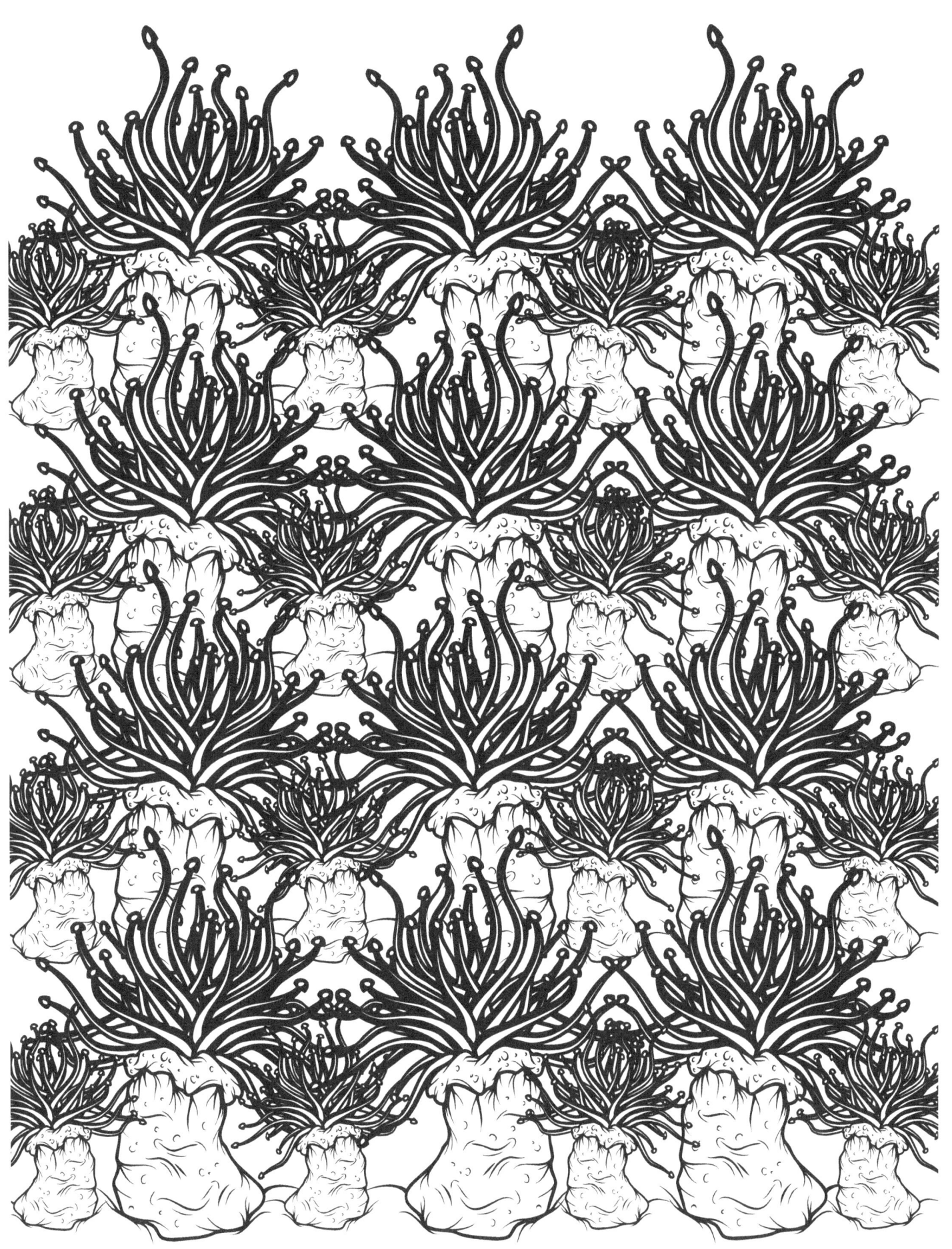

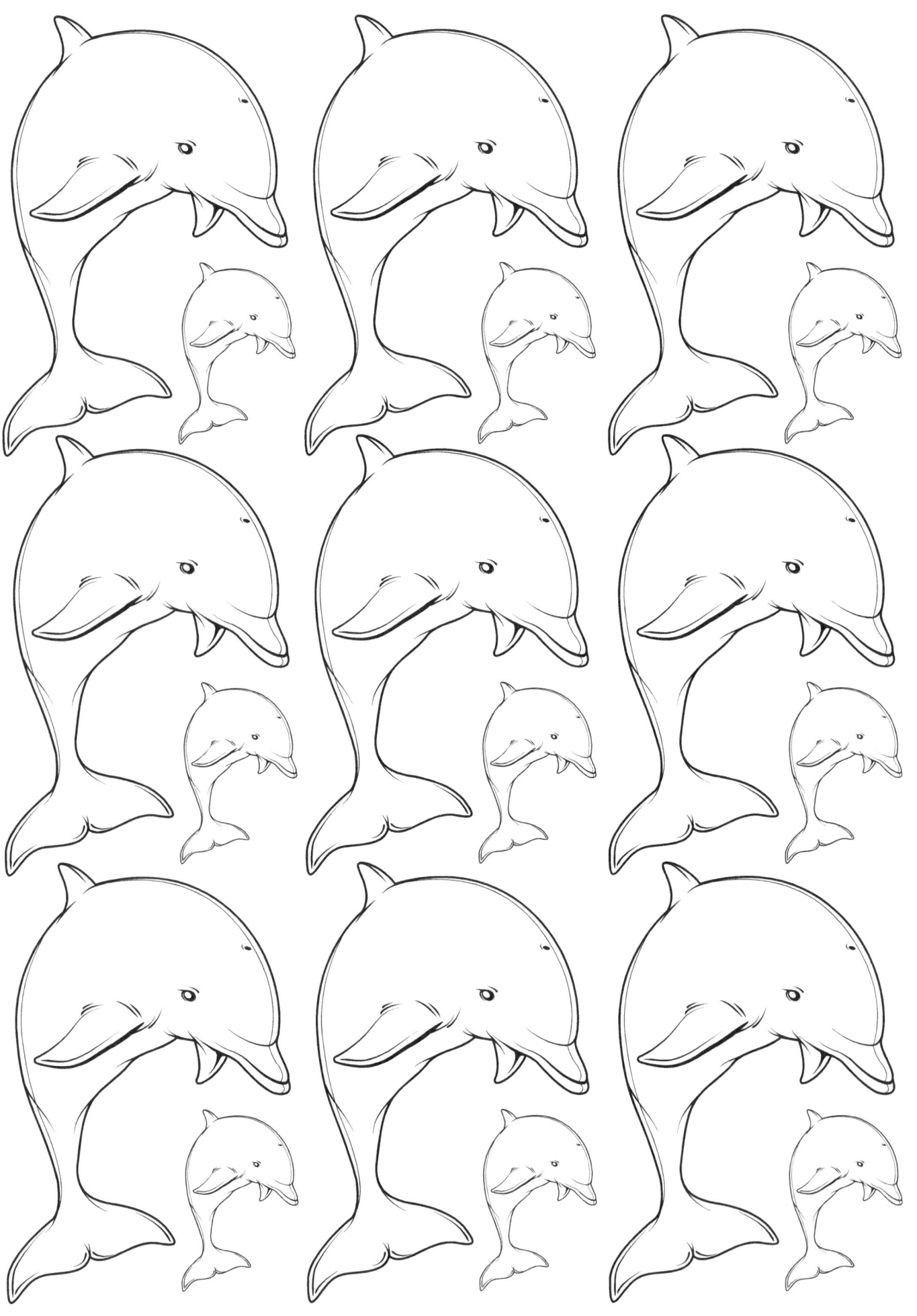

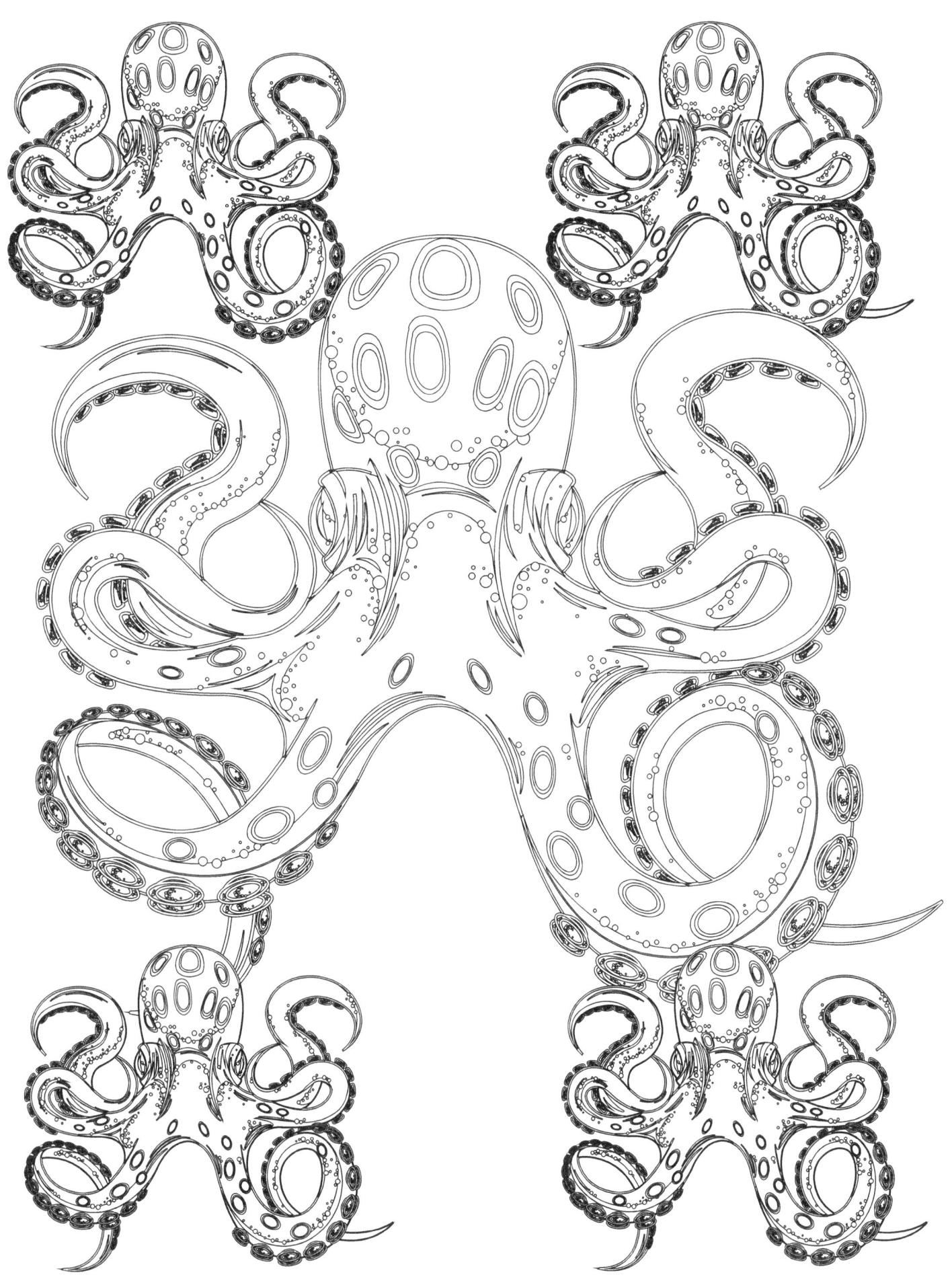

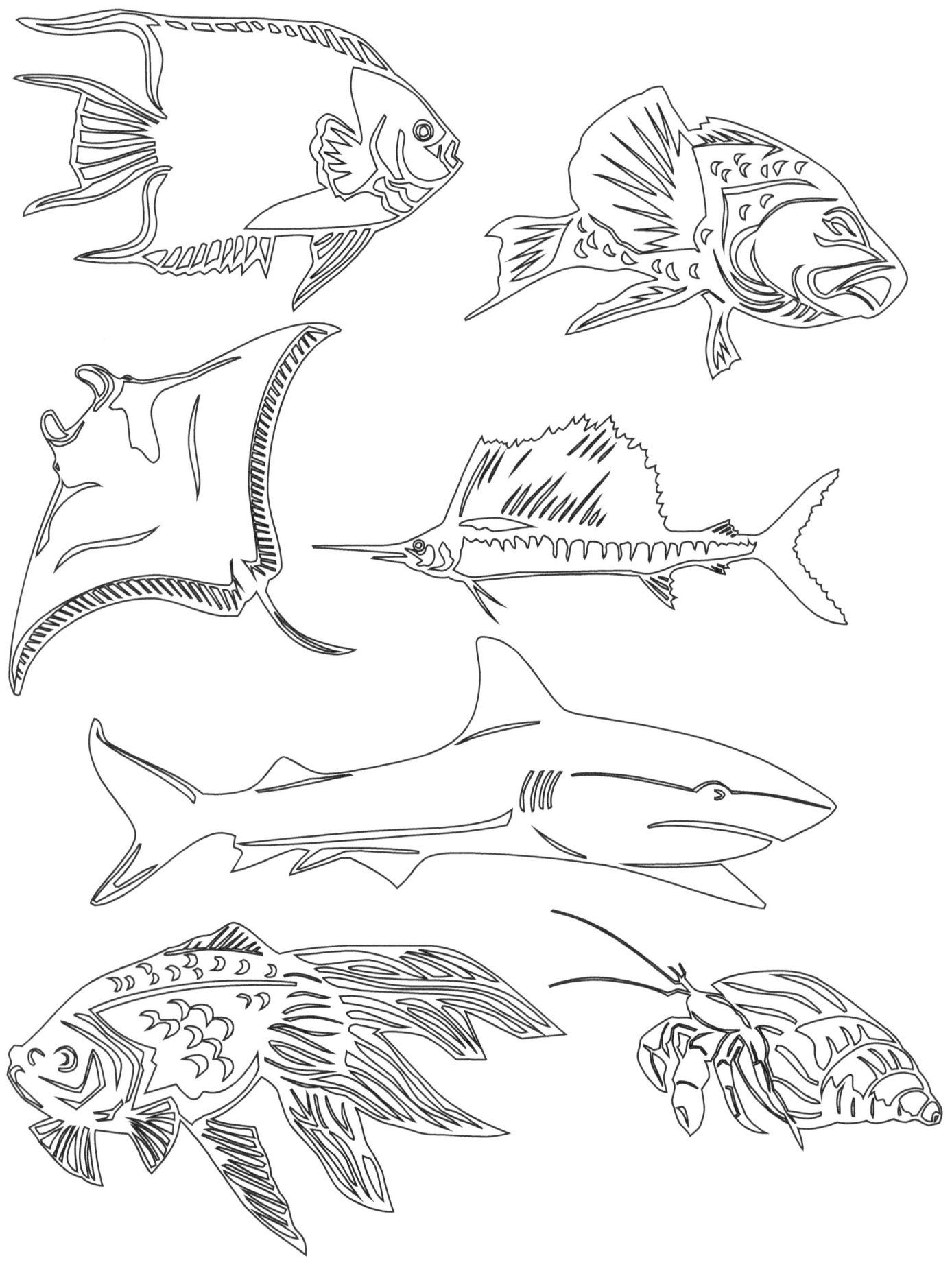

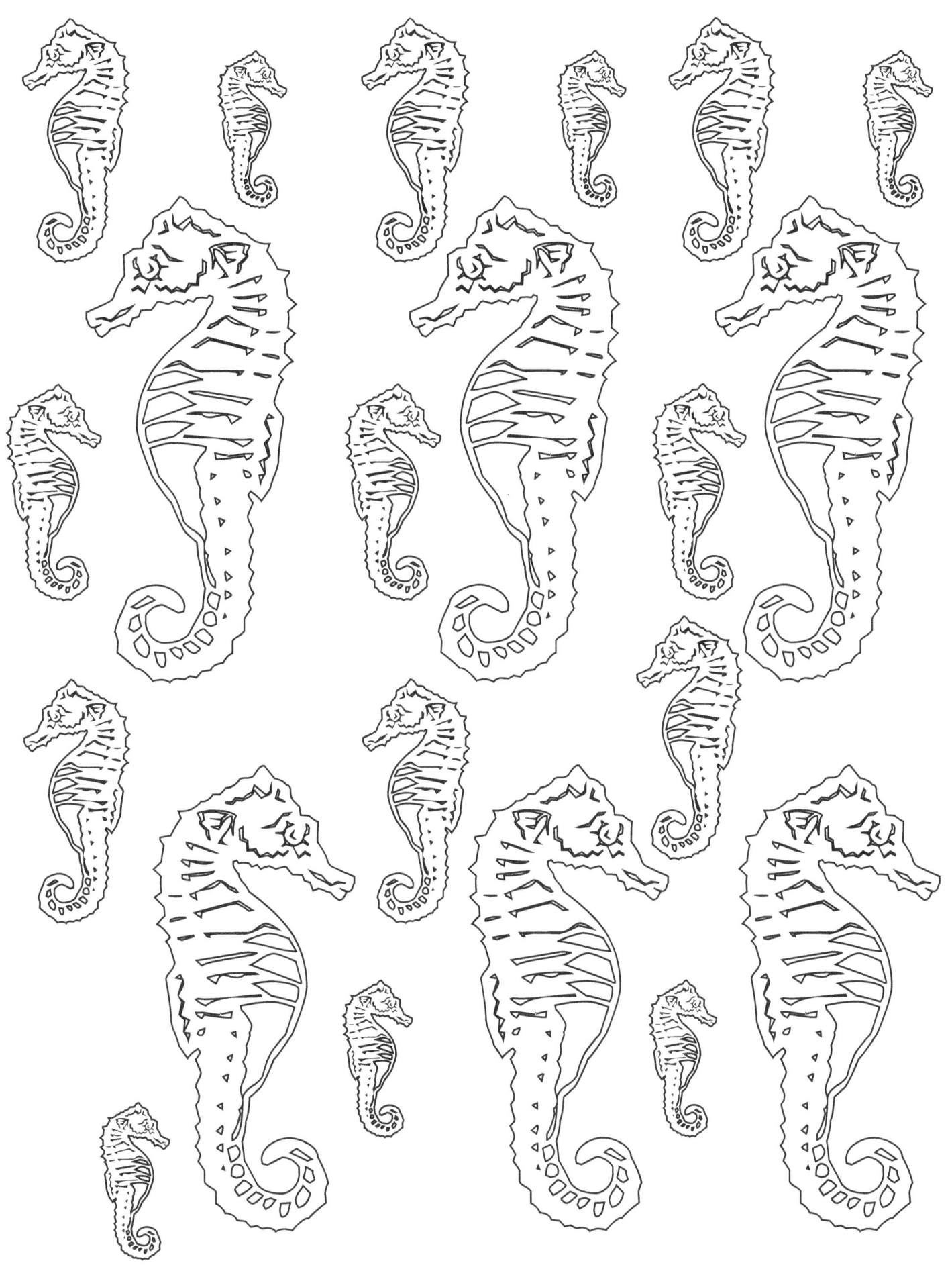

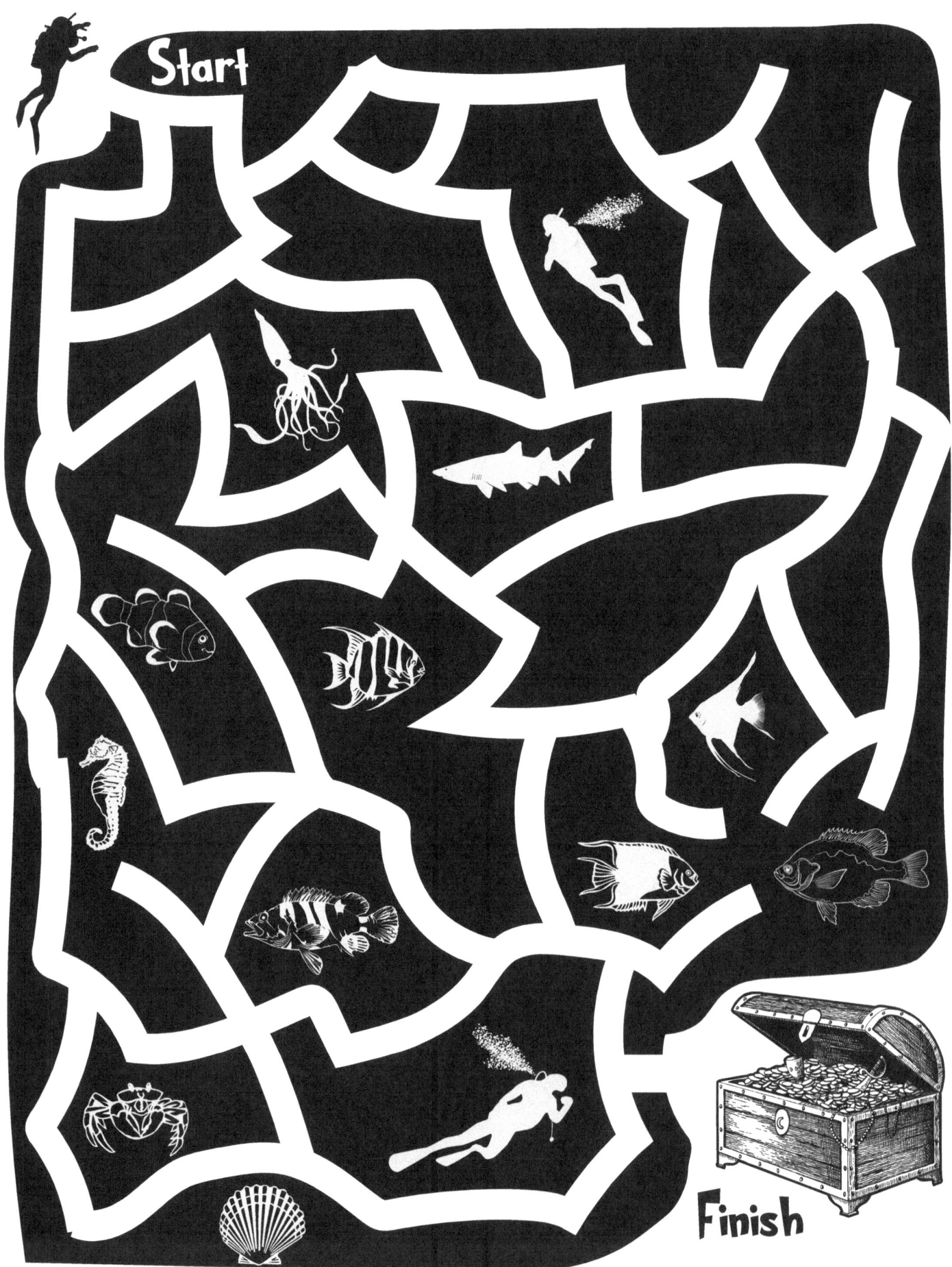

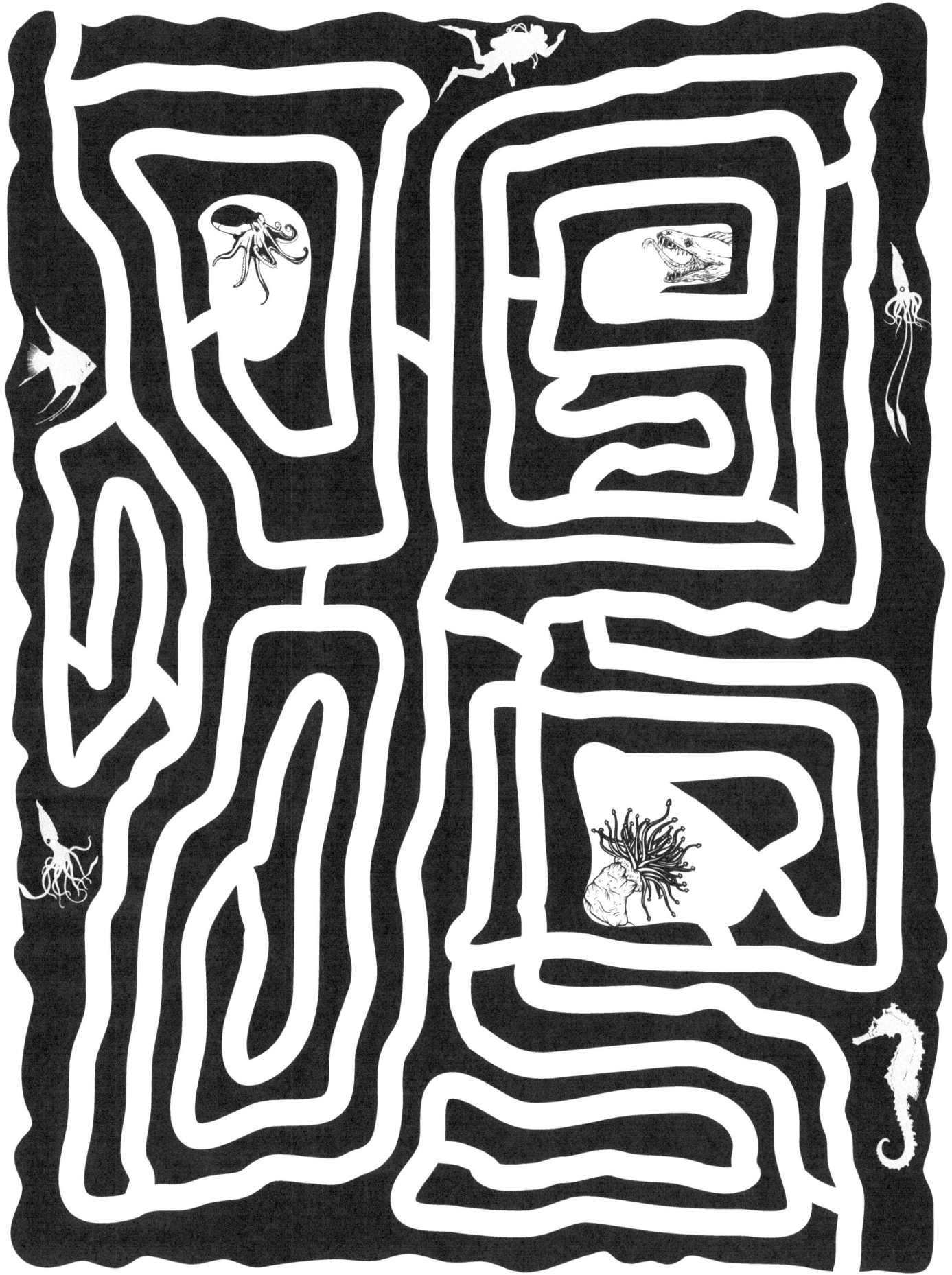

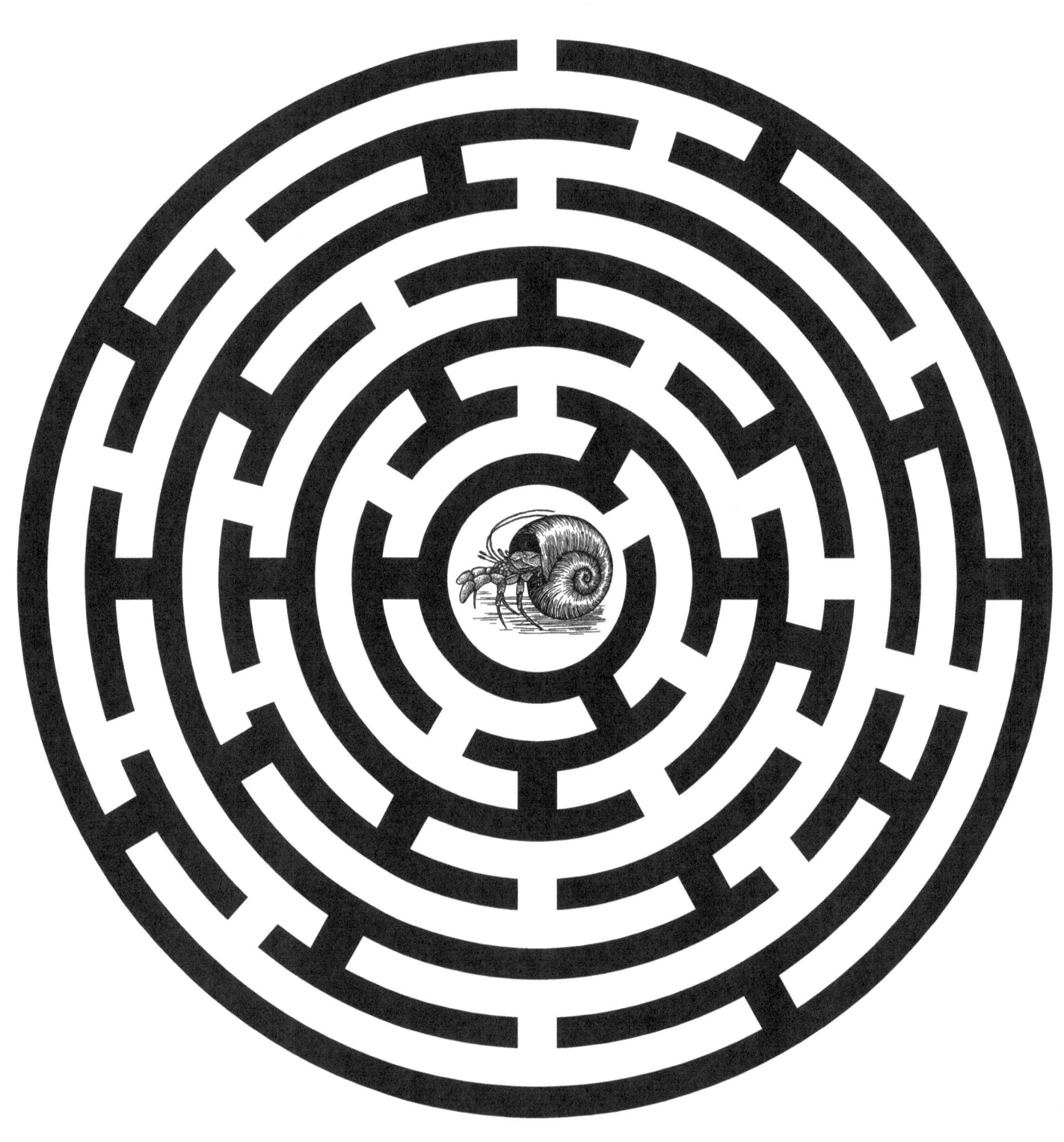

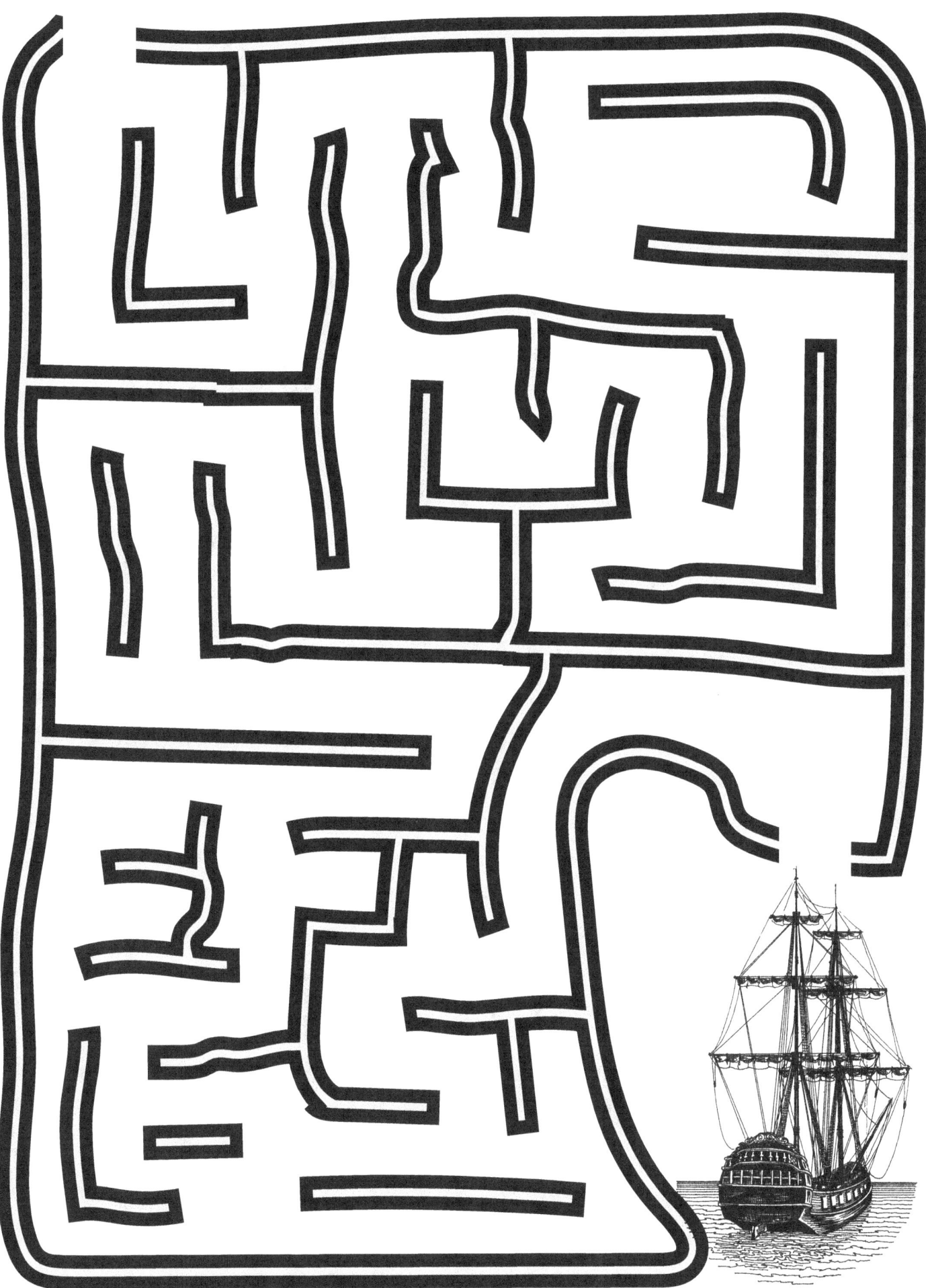

Start

Finish

Start

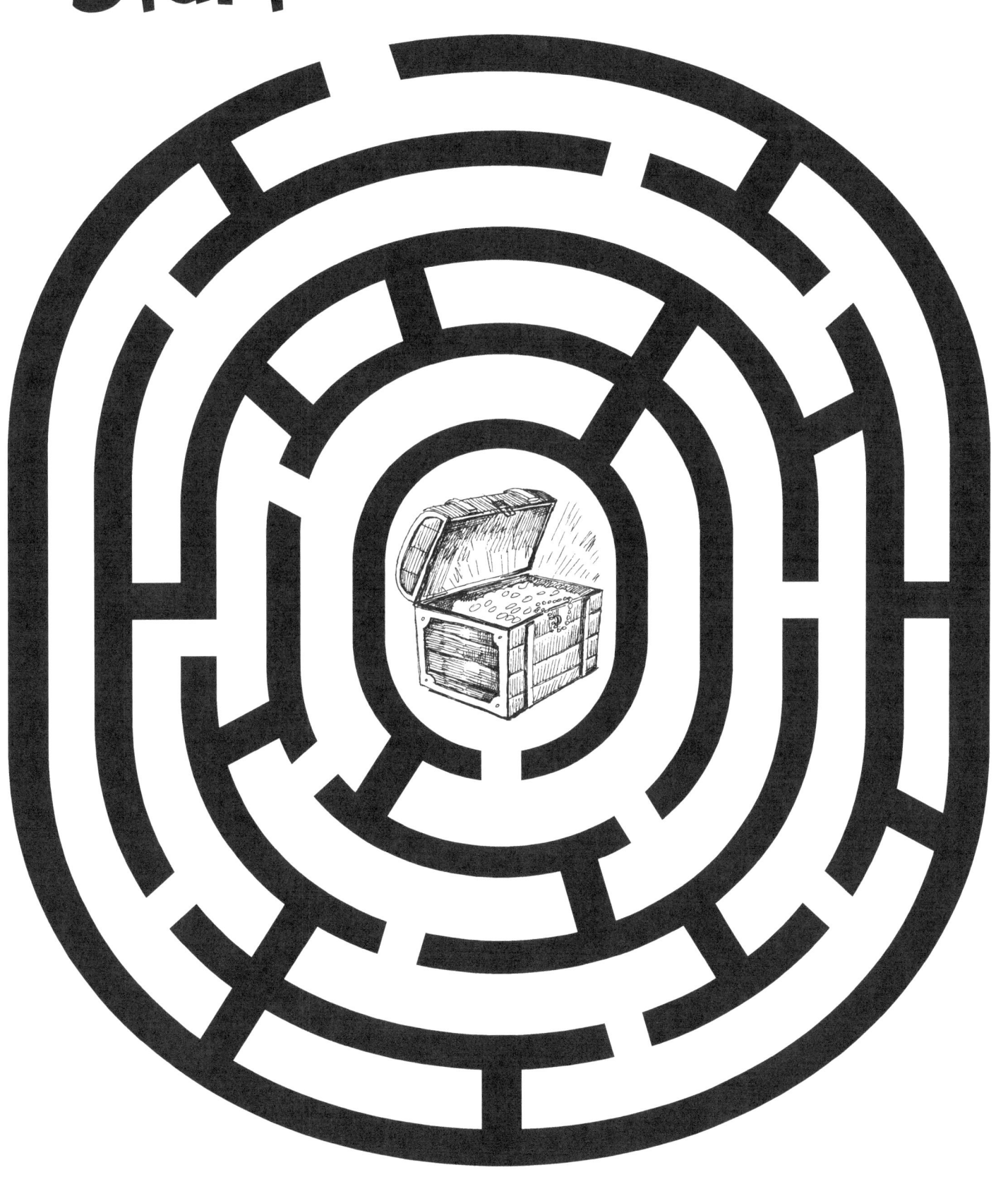

Start

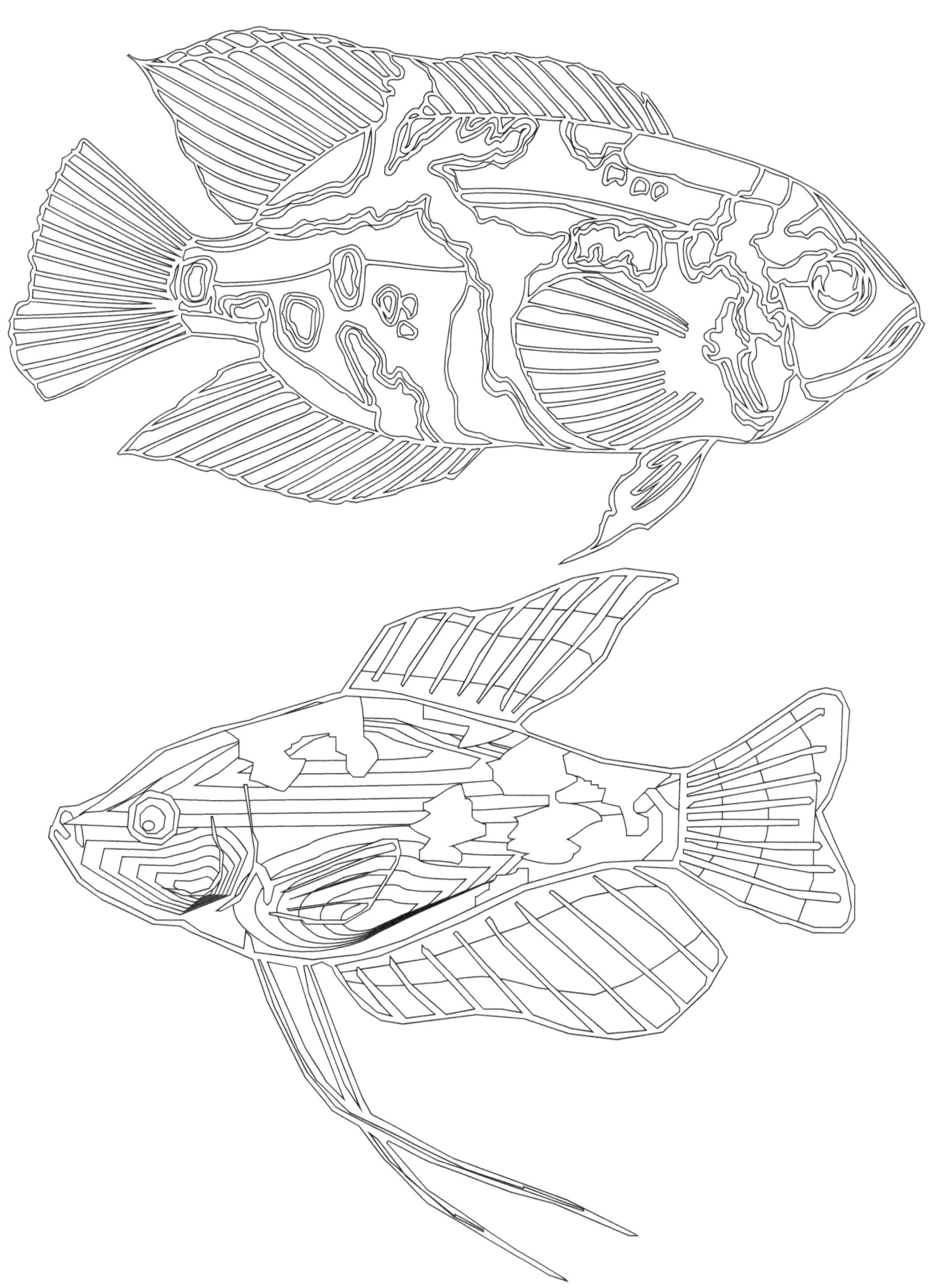

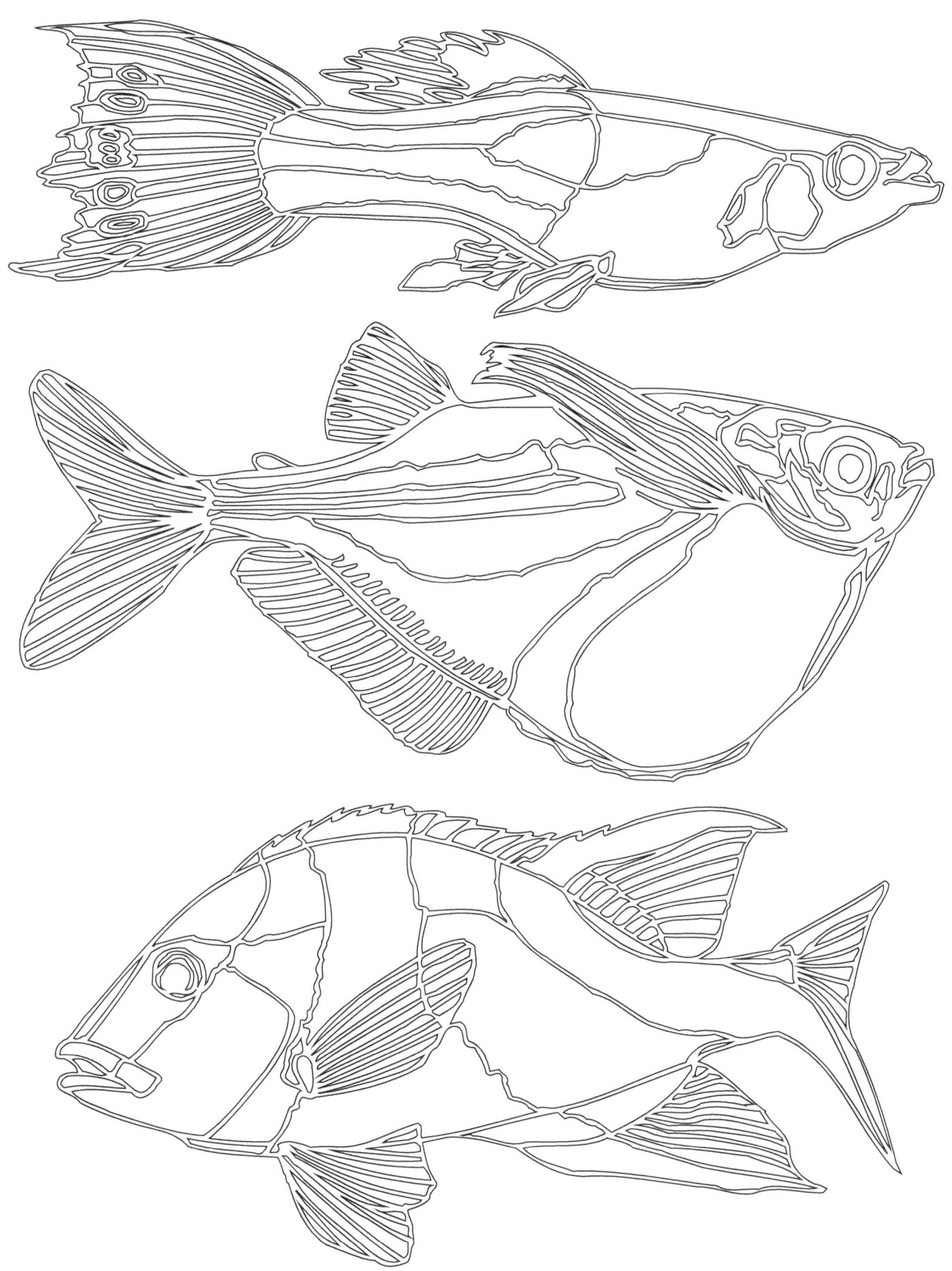

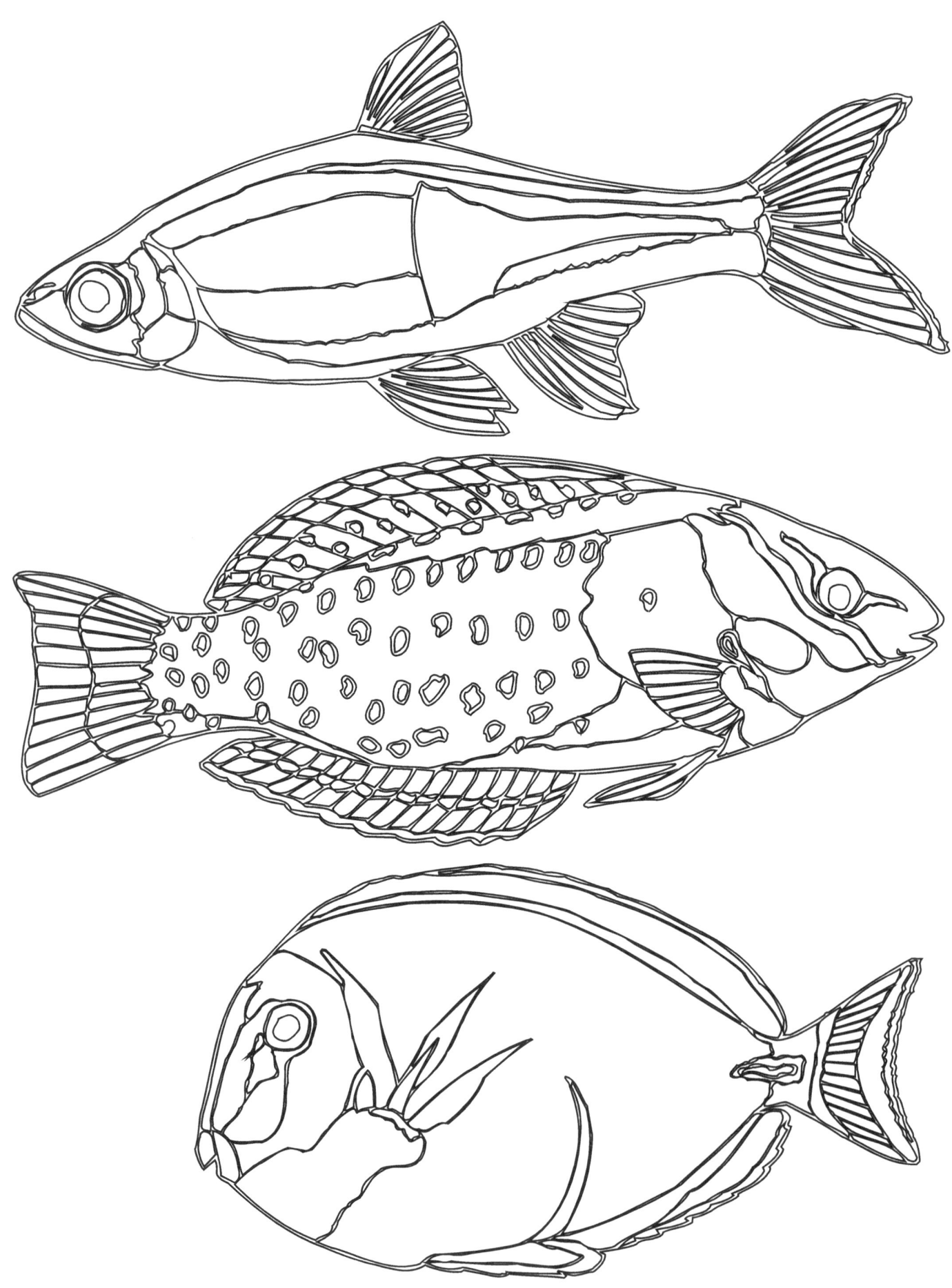

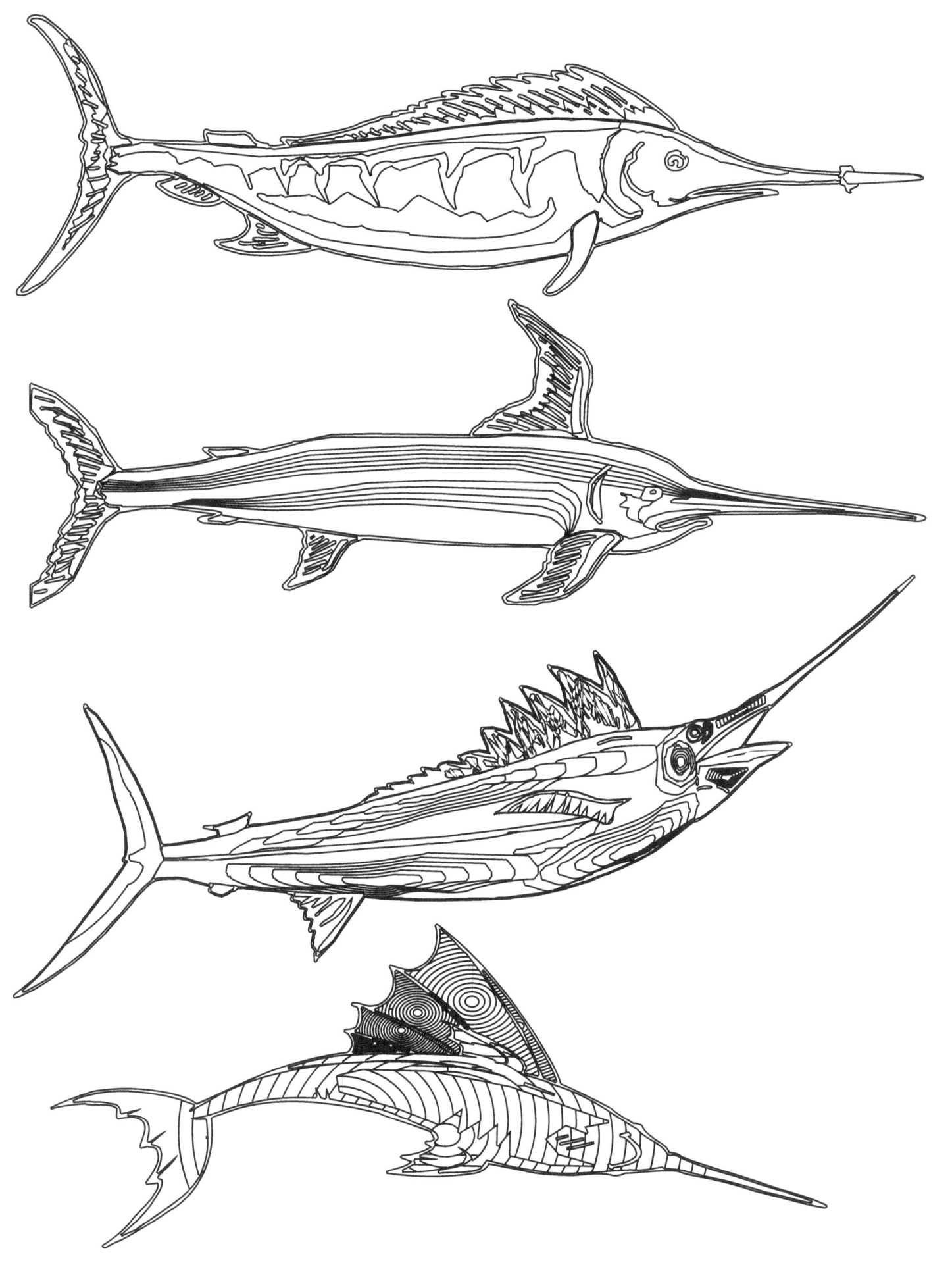

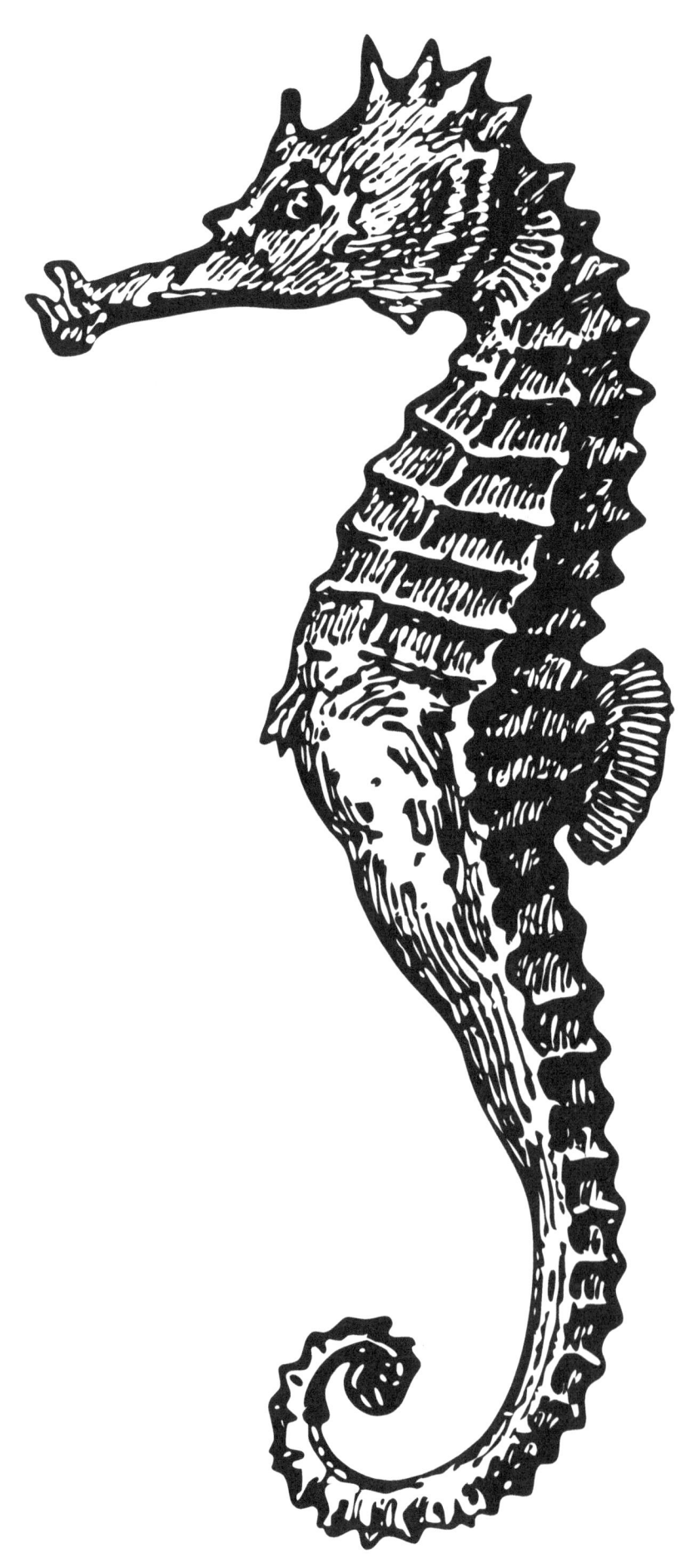

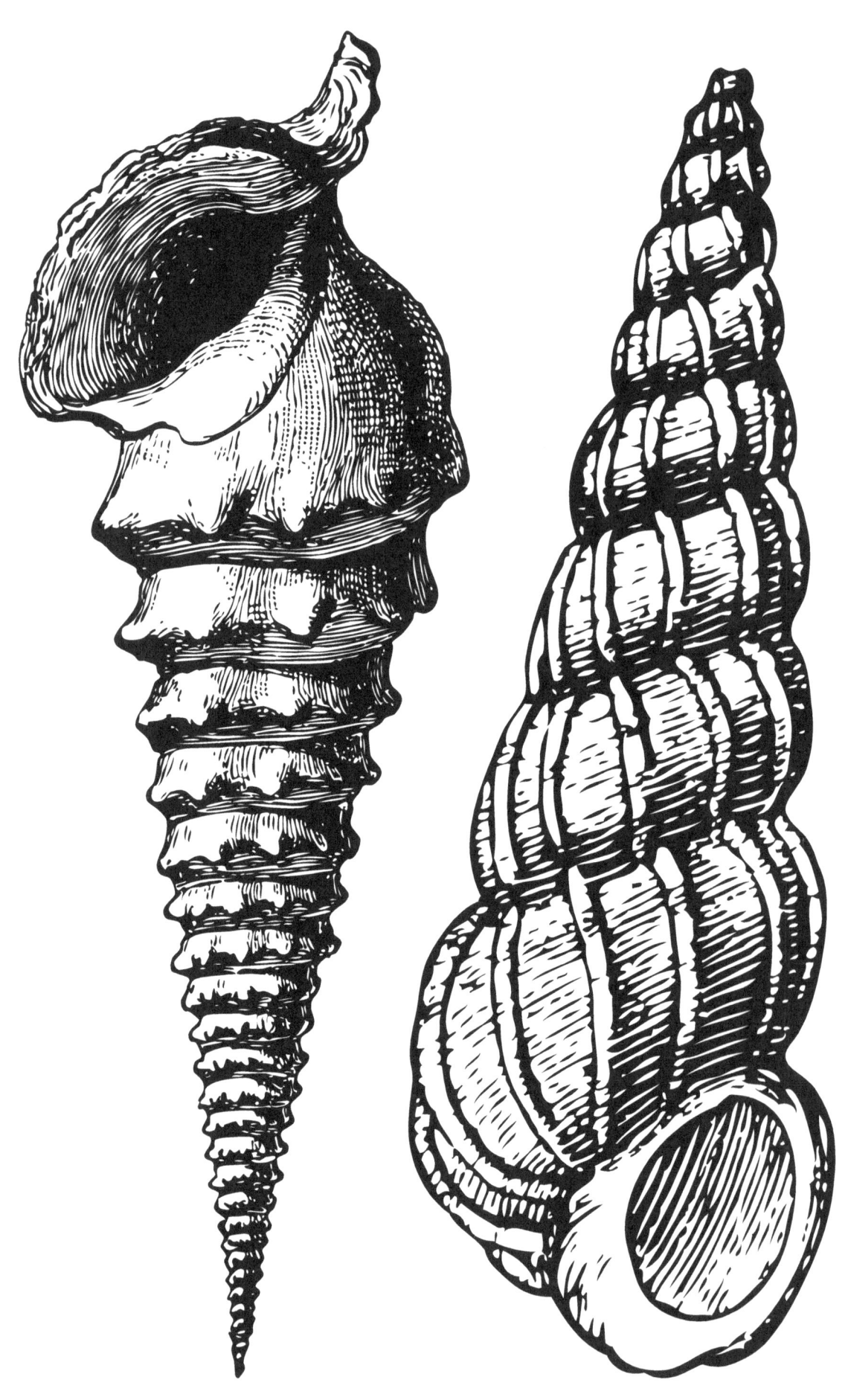

www.ingramcontent.com/pod-product-compliance
Lightning Source LLC
Chambersburg PA
CBHW081253180526
45170CB00007B/2406